THE ART OF DRAWING AND CREATING

MANGA

Advanced Techniques

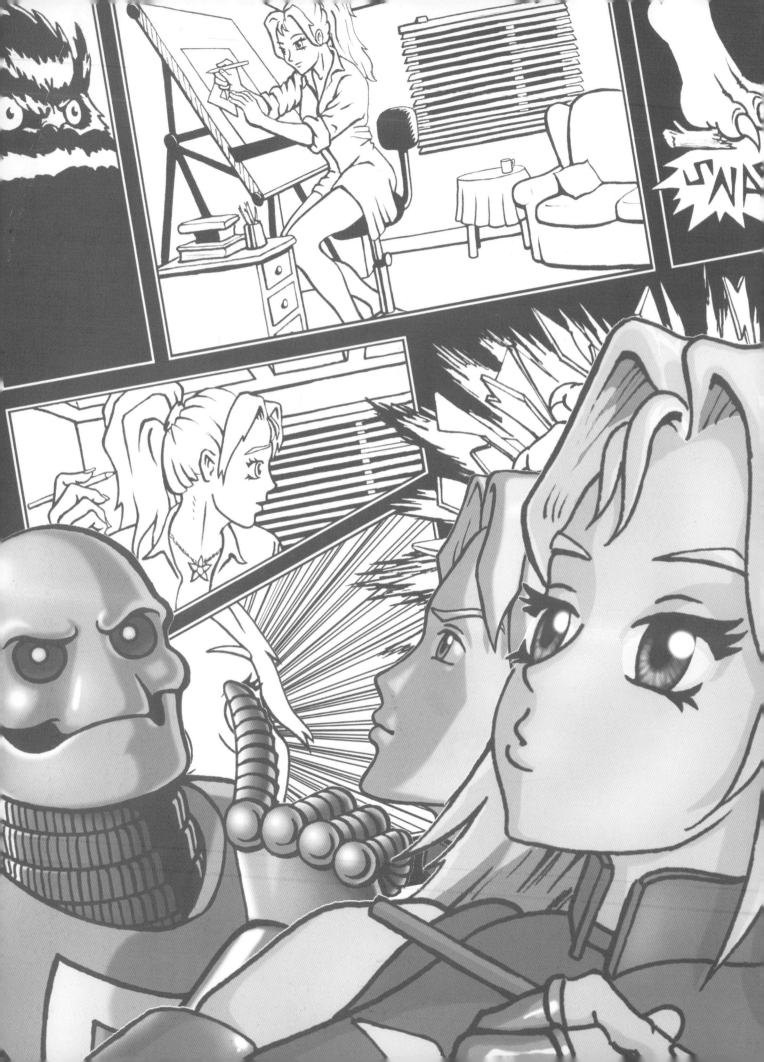

THE ART OF DRAWING AND CREATING

MANGA

ADVANCED TECHNIQUES

PETER GRAY

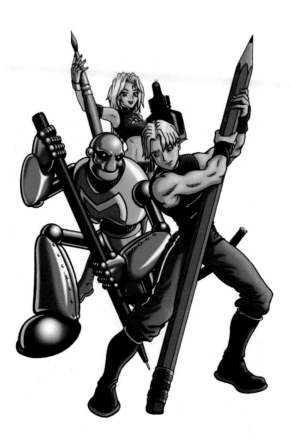

ARCTURUS

Arcturus Publishing Limited
26/27 Bickels Yard
151–153 Bermondsey Street
London SE1 3HA

Published in association with
foulsham
W. Foulsham & Co. Ltd,
The Publishing House, Bennetts Close, Cippenham,
Slough, Berkshire SL1 5AP, England

ISBN-13: 978- 0-572-03024-7
ISBN-10: 0-572-03024-X

British Library Cataloguing-in-Publication Data: a catalogue record
for this book is available from the British Library

This edition printed in 2006
Copyright © 2004 Arcturus Publishing Limited/Peter Gray

Cover design by Alex Ingr/Steve Flight
Book design by Steve Flight
Artwork by Peter Gray
Digital colouring by David Stevenson

Printed in China

CONTENTS

If you're into drawing manga, chances are you've already copied characters from your favorite comics or animations. You may also have created and developed characters of your own, or maybe you have followed the step-by-step instructions in other books of this series to draw the characters found in them.

Interesting, dynamic, and glamorous characters are at the heart of what manga is about, so they are a logical starting point for drawing in the manga style. But at some point, you'll want to do more with your characters, so this book tells you how to put characters into contexts that will show off their best attributes.

You'll learn how to design backgrounds, compose pictures, and tell stories with your characters. Whether you enjoy futuristic fantasies or gritty urban tales, romance or horror, the principles of making your characters come to life can be transferred from one genre to another. So there's plenty you can learn from each and every one of the exercises provided in this book—even the ones that might not involve the types of characters or action that you are mainly interested in drawing.

The other books in this series cover how to draw and create manga women, action heroes and heroines, and mechas and monsters. Here we'll look at some of the characters from those books again and create environments for them.

Don't worry if you don't have the other books—the characters are only used to demonstrate picture-making principles, and you can apply these principles to any characters and scenes you choose to create.

THE TEAM

Let me introduce you to our friendly trio of guides. That's Duke on the left. He and Daisy (the pretty one on the right) are 17. They're stronger than most ordinary toonagers and good at defending themselves—something they learned from growing up on the rough side of town. They only use their strength when they have to, though. They're also very good at drawing manga.

Magnus is in the middle. He's a robot, as you probably realize, but one with an intelligently programmed brain.

These loyal friends will be helping to demonstrate some of the theory involved in taking your manga drawings to the next level.

BASICS

Before I start showing you any advanced techniques, I want to make sure you're up to speed on the basics. We'll begin by looking at the materials you'll need—pencils, pens, brushes and ink, eraser, and paper—and how to choose them for the particular job in hand.

After you have looked at materials I want you to study the elementary rules of picture design and color theory, since you'll need a firm grasp of them if your drawings are to achieve maximum impact. Don't worry if theory's not your bag and you'd much rather be doing. This is one instance where you have to put the theory into practice if you're going to really make the grade as a manga artist. So persevere, and soon you'll find those rules becoming second nature and you'll use them as a matter of course.

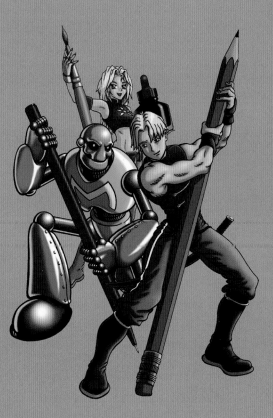

BASICS
BASICS
BASICS
BASICS
BASICS
BASICS
BASICS
BASICS
BASICS
BASICS
BASICS
BASICS
BASICS
BASICS
BASICS
BASICS

One of the biggest mistakes artists often make early in their development is to buy all kinds of materials, thinking these will make them a better artist. But you really don't need much at all.

Pencils

Pencils are graded from 3 to 1. A number 3 pencil is hard, and a number 1 pencil is soft. Ordinary pencils used in schools and at home are number 2. They are good general-purpose pencils, but a harder pencil like a number 3 is more useful for sketching light guidelines. A softer pencil like a number 1 will help you darken your drawings. Using a number 2 mechanical pencil produces a constant fine line. Non-mechanical pencils will need sharpening regularly.

Eraser

You'll be drawing frameworks to help form your pictures, so these frameworks, and any mistakes you make along the way, will need to be erased. Any eraser should do the trick—just make sure it erases cleanly.

Paper

Most of the drawings in this book were done on cheap photocopier paper. You only need to worry about paper quality when you are using more advanced materials.

Pens

Traditional manga artists use a metal-tipped pen and black ink. The pen produces lines of varying thickness, depending on how hard it is pressed onto the paper. An easier alternative is to use good quality felt-tipped drawing pens.

Brushes and Ink

A brush and some black ink can produce a range of different effects. They are also useful for filling in large areas of solid black. Some manga artists use brushes for all their black line work. Choose good quality fine round-tipped watercolor brushes. White ink is useful for covering up mistakes and adding effects.

Color

Not long ago, manga artists did all their coloring by hand using watercolors or acrylic paints. Today, most manga artwork is colored on computer—most of the artwork in this book is colored that way. If you don't have access to a computer or the appropriate software, that's okay—the older methods can produce stunning effects.

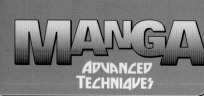

Composition

Composition is one of the first things to consider when making a picture. It's all about the elements you want to include in your picture and where you place them. This may sound simple, but good composition takes some thought.

Basic rules

Here we're going to look at the most basic compositional rules. Knowing these will help you to make decisions about your own pictures. Bear in mind that no two pictures are the same and that it's sometimes necessary to break rules—but rules can only be successfully broken when you know what they are!

Portrait format

A picture that is taller than it is wide is known as portrait format. The two pictures on this page show Magnus in a portrait-shaped frame.

① Bad placement

When people are taking photographs, you'd be surprised how often they make the mistake of automatically placing the focal point of the picture—in this case, Magnus's head—smack in the middle of the frame. The same thing can happen when someone draws a picture. Here Magnus is placed too low. His head sits halfway down the frame, as

marked by the green line. There is too much empty space above his head and he looks like he's going to drop out of the bottom of the picture.

② Vertical placement

The height of an object within the frame is known as the vertical placement. This picture shows good vertical placement. Magnus fills the frame nicely, without too much empty space and without having any of his body parts cropped off.

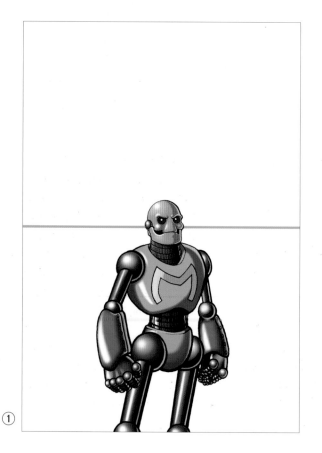

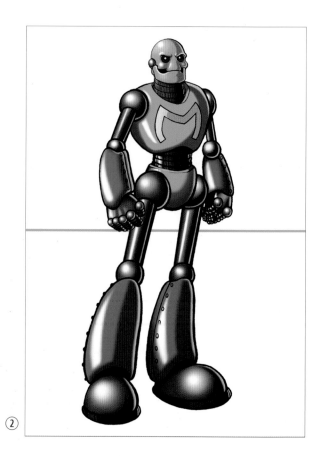

①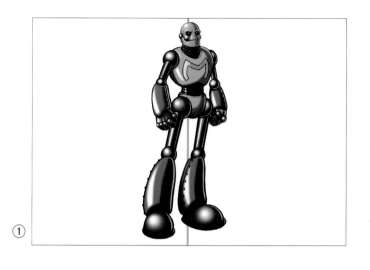

②

③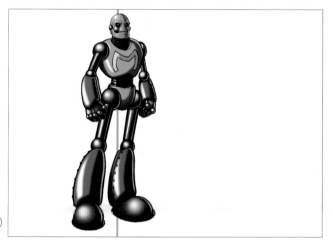

④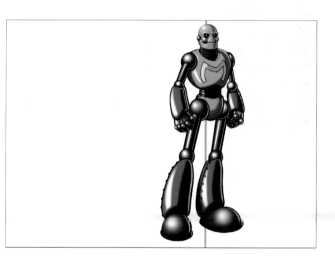

Landscape format

The pictures in these frames are wider than they are tall. Called landscape format, it is normally used by photographers and artists when they want to capture a wide expanse of scenery.

① Horizontal placement

The position of an object along the width of the frame is known as the horizontal placement. Here Magnus has been placed centrally. Although this can sometimes work well, depending on the other elements, more often than not it looks boring and should be avoided.

② Golden section

It is generally accepted that pictures work better when the objects are placed to the left or right of center. Artists living in ancient Greece worked out a complicated geometrical equation known as the golden section, and today's artists still follow this rule. In simple terms, it states that objects should be placed just over a third of the way in from the picture's edges.

③–④ Moving left or right

Moving Magnus to the left or right and placing him roughly on the lines of the golden section divisions immediately makes for a more interesting picture. The angle of his body also changes his relationship with the rest of the picture space. In 3, he's facing into the picture, suggesting involvement with any background we might add. Picture 4 suggests the opposite because Magnus is angled away from the main area of the picture.

MANGA
ADVANCED TECHNIQUES

Color Theory

The colors you use for a picture will have a major impact on its final look and feel. Here Magnus is proudly modeling some simple color schemes. The rules behind these color schemes also apply to creating backgrounds.

① **Primary colors**
Red, blue, and yellow are the basic colors that all other colors are mixtures of. They are called primary colors. If you can only afford three colored pencils, pens, or paints, go for those colors.

② **Secondary colors**
Green, purple, and orange are called secondary colors. Each one is a combination of two primary colors. In these three pictures, the two colors of Magnus's limbs are mixed together to make the color of his chest armor.

③ **Full spectrum**
The three primary and three secondary colors represent the full spectrum of pure bright color, like you would see in a rainbow. Putting all of these colors together in one picture can be overpowering, so it's usually wise to limit the number of colors you use.

④ **Tints and shades**
White and black can change a color's qualities. When colors have white added to them, they are called tints and will look pale and pastel. When colors have black added to them, they are called shades and look darker. Using different tints and

shades will make your pictures look much more sophisticated. Here the same color has been used for each of Magnus's body parts, but for the picture on the left, white was added to each of the colors to produce a pastel version. For the second picture, black was added to each color to produce a darker version.

⑤ **Complementary colors**
Some colors go together better than others. Every primary color has one secondary color as its complementary color, which is a combination of the other two primaries. So, for example, red is complemented by green (blue plus yellow) and yellow is complemented by purple (red plus blue). Good combinations can be made by using complementary colors. Here Magnus is dressed in various tints and shades of blue and orange (yellow plus red).

⑥ **Harmonious color schemes**
To help convince you that you don't always need to use lots of different colors, this picture has been colored using only tints and shades of green, which were created by adding white or black to the color. There is certainly no chance at all of any colors clashing here!

①

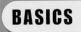
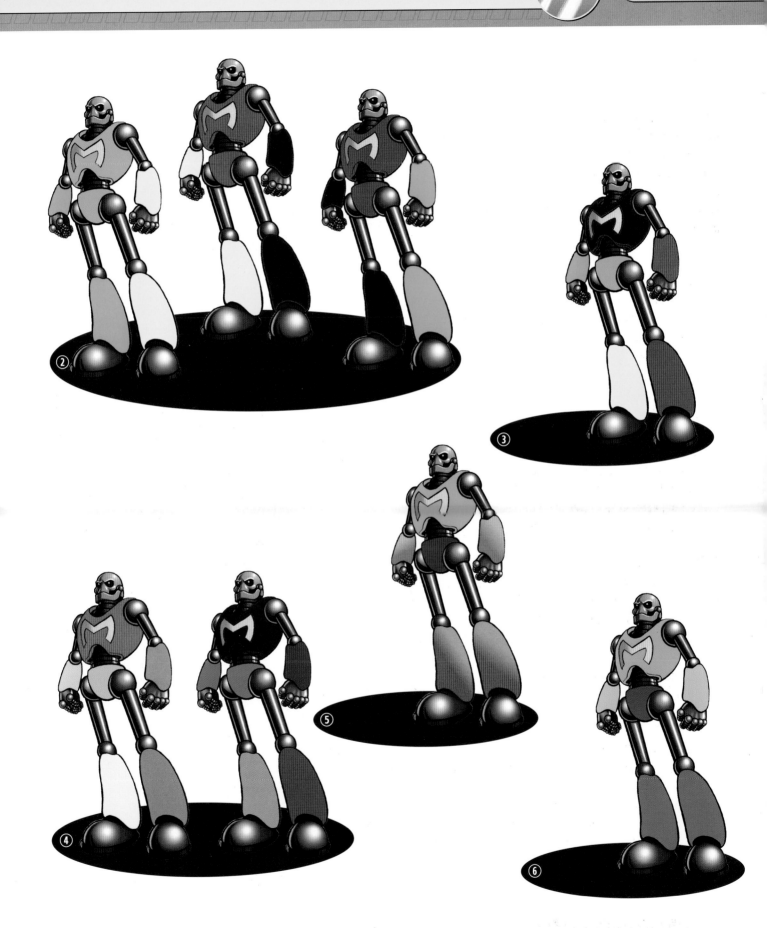

BACKGROUNDS

There are no end of backgrounds that you could create for the characters you draw.

In this section, we'll be looking at abstract backgrounds that work to exaggerate the features of your characters. We'll also look at the creation of full background scenes that you can use to place your character in a particular setting. These scenes range from the kinds of settings you might be familiar with from the world around you, to original futuristic environments.

Although you'll have plenty of opportunity to use your imagination and create some weird and wonderful worlds, there are still some rules you will need to follow, so here you'll find out how to make all these scenes have a convincing feel.

A good background should be able to more than double the impact that your character would make on its own, so I'll give you some tips on getting the characters and backgrounds to work well together.

Successfully combining these is partly down to use of color so we'll need to look at this too.

If you've got other books in this series, you can work with the characters you've drawn from these—as I have done here. Otherwise, you can apply the techniques you learn here to create backgrounds for some of your own characters.

BACKGROUNDS
BACKGROUNDS
BACKGROUNDS
BACKGROUNDS
BACKGROUNDS
BACKGROUNDS
BACKGROUNDS
BACKGROUNDS
BACKGROUNDS
BACKGROUNDS
BACKGROUNDS
BACKGROUNDS
BACKGROUNDS
BACKGROUNDS
BACKGROUNDS
BACKGROUNDS
BACKGROUNDS

Abstract Backgrounds

A recurring feature of manga artwork is the abstract background. A whole range of textures, colors, and tones (light and dark areas) are used to help show how characters are feeling or how we, the viewers, are invited to feel about them. Daisy is going to model some of the more commonly used types of abstract background.

① **No background**

Without adding any kind of background to this picture, you can see that there is very little here to indicate any kind of mood or sensation. The picture looks bland and doesn't have the impact of professional manga artwork.

② **Contented feel**

A little splash of color and some simple cloud shapes instantly convey a feeling of contentment. These are bright, fresh colors that we associate with warm, sunny days.

①

②

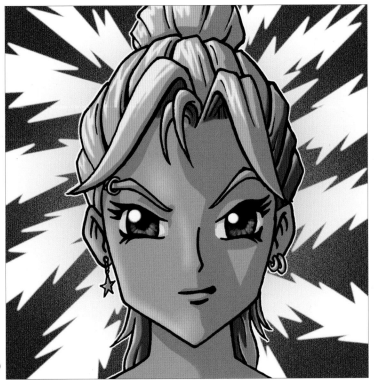

③ – ④ **Evil look**

Abstract backgrounds don't just work to convey the mood of a character—they can also help to show the personality. In the picture, Daisy's evil twin, Detta, is enhanced by manga-style lightning bolts and flame designs. Color is also important here—the deep reds and purples express rage and vindictiveness.
»

③

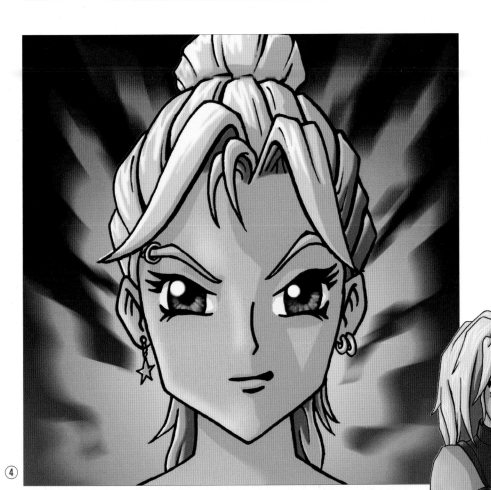

④

A great deal of expression can be achieved without you having to draw anything difficult. The whole purpose of any kind of art is to communicate, and if you can say what you want with simple effects, there's no point in complicating things.

«

⑤–⑥ **Speed lines**

This is a device that manga artists use regularly. Lines of varying number and thickness radiate from a character to emphasize a range of emotions—their meaning will depend on the story they are used in and the expression on the character's face. They may suggest anything from a sudden realization or shock to determination or excitement. The background color can also enhance the desired effect.

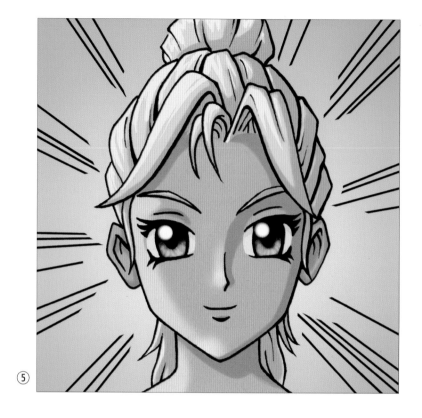

⑤

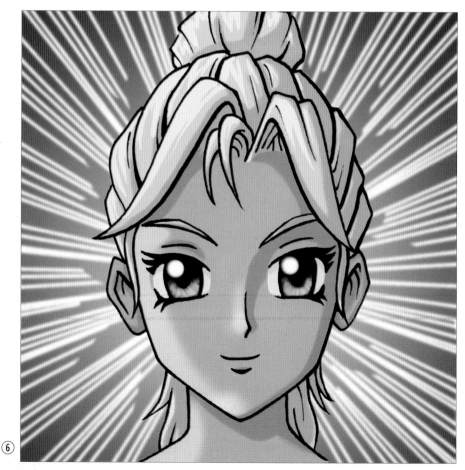

⑥

⑦

⑦ – ⑧ Other effects

In addition to stressing a character's personality and expression, background effects can also help to make a gesture more powerful—a raised finger can be imbued with magical qualities, while a clenched fist can be made more triumphant.

When you read comics or watch animations, look for the abstract effects that are used, then try to emulate these in your own artwork. You can make up your own effects, but they have to work—make sure they mean what you want them to.

⑧

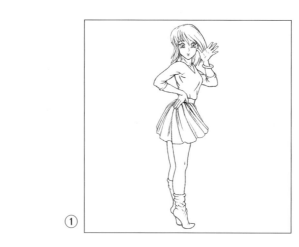

①

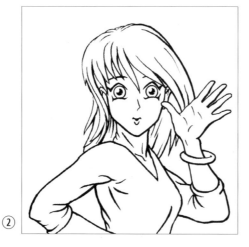

②

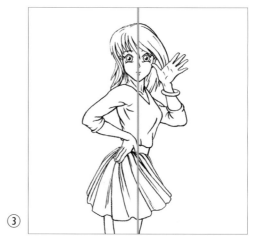

③

Love at First Sight

Let's start with a simple, static figure. A lonesome Romeo has just set eyes on Tellima for the first time and is instantly sure that she is the girl of his dreams. At this moment, nothing else exists for him. We are going to create a background that aims to express his emotion. We need to produce the effect of everything pulling toward the girl, yet at the same time, she should be radiating out of the picture. The format I've chosen is a precise square. Next we need to decide how to place Tellima in the square.

① Figure—too small

Here, Tellima is really too small—she doesn't fill much of the space, so she is in danger of being swamped by the background.

② Figure—too big

Tellima certainly isn't going to get lost in this picture, but she doesn't leave much room for adding an effective background. Although we want her to attract our Romeo's attention, she's now too close for there to be any kind of mystery attaching to her.

③ Good-size figure

This is a much better size. The legs will be cropped off, but they're not important to the overall feel. For this picture positioning Tellima centrally would be a good idea. By doing this I'm breaking the golden section rule (see page 11) but for a good reason—since I want the figure to be the sole focus of interest.

④ **Bad gradients**

Here I've tried to use the tone of the background to focus attention on the girl, but it isn't quite producing the desired effect—it seems to be pushing the figure forward.

⑤ **Good gradients**

This is more like it. The background tone gives the figure an appealing halo effect—it almost seems like we're looking into a tunnel with a light at the end of it.

⑥ **Bad radials**

To exaggerate the effect of the background, I'm going to add lines radiating from behind the girl. Here though the lines don't quite work because they are too haphazard.

⑦ **Good radials**

Drawing all of the lines radiating from a single point makes them look more orderly and elegant.

⑧ **Color rough**

A color you want can often be made by applying one color felt-tip pen over another. But if you want to use pure bright colors, you'll be limited by the range of colors those pens come in. They're fine, though, for dashing off a quick color rough to help you visualize your ideas and make sure they work. For the background, I've drawn a series of concentric heart shapes around Tellima, and starting in the center, I've colored them using increasingly darker pinks. For my final artwork I'll use only one pink and make different tints and shades of it by adding white or black. Instead of making my radiating lines black—like they often are in manga comics—I'll use diluted white ink to create the effect of shafts of light. I'll also add some spots of white ink to provide a bit of sparkle.
»

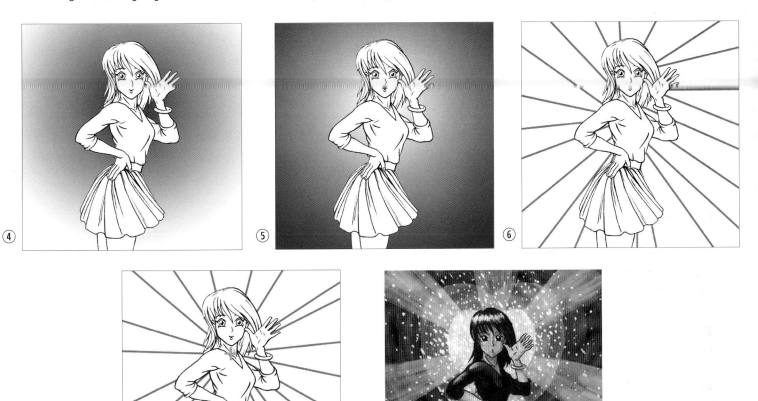

④ ⑤ ⑥ ⑦ ⑧

⑨

<<

⑨ Final color background

On a computer I can easily replicate my color rough and produce a very polished look. Similar effects could be achieved with traditional materials, although it would take a lot longer, and every color would have to be meticulously applied.

Completed artwork

With Tellima in place the picture is finished. I slightly blurred her for a soft-focus effect, and partially erased her legs so as to keep the attention on the top half of the picture.

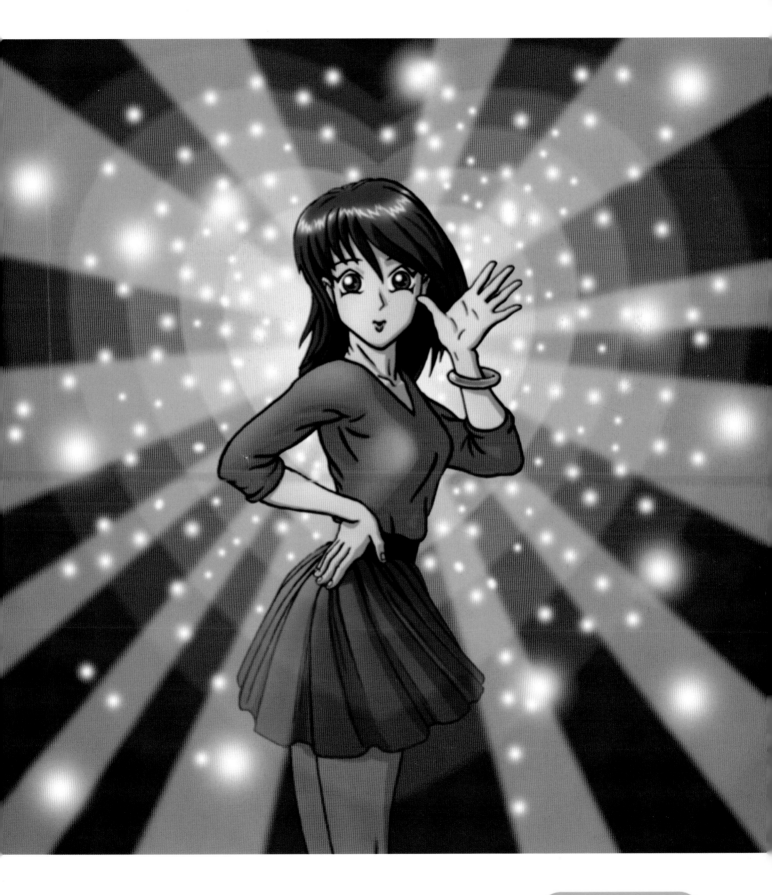

Warrior Woman

Compared to Tellima, this pose has more dynamism and drama; you can tell that the character has plenty of attitude. The challenge this time is not so much to seduce the viewers, but to send shivers down their spines! The background needs to convey movement as well as power and attitude. I also want to capture something of this character's wild spirit—she is one feisty manga babe.

① Figure—too big

Here, our warrior woman is too large to convey movement. A moving figure needs space within a picture.

② Bad placement

This is a better size for the figure and she is at a good height, but the central positioning along the horizontal axis is not right—it's far too static for our requirements.

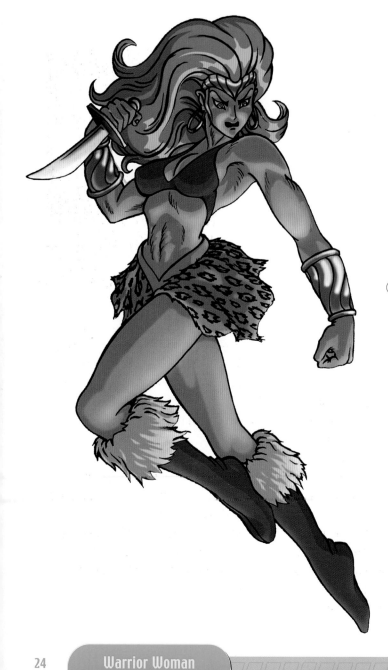

①

②

③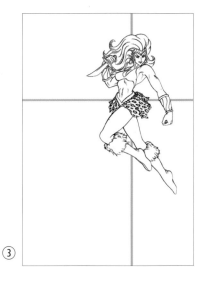

④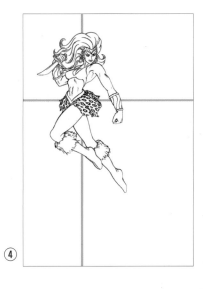

⑤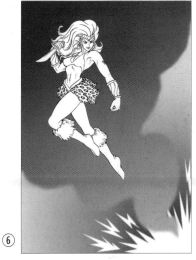

⑥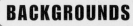

③ Using the golden section
Here I've moved the warrior away from the center of the picture by applying the golden section, as explained earlier, on page 11. This is better, but her face is turned to the bottom right here, which means that whatever she is looking at is off the edge of the picture, so the picture isn't quite right.

④ Good placement
Placing the figure at the top left conveys the sense that she has reached the peak of her movement and is looking back toward where she leapt from. Instinctively, I think this position works well.

⑤ Adding a background
The background for this picture needs to be suitably dramatic. The first things to consider are the broad shapes and tones. To create these, I usually sketch out little pictures that are just a couple of inches high, on a single piece of paper, to try out different combinations of lines and shadings. You can work out a lot of things with simple pencil sketches like these. Artists call them thumbnails. At this early stage of a

new design, these pictures don't need to be very big or complicated. This picture shows the effect I arrived at with my thumbnails. The basic tones and shapes give the thrust and mood I'm after.

⑥ The detail
Working up the detail gradually as I went along, I refined the shapes and added a light source. Even at this stage, I'm already thinking about the textures and elements that the finished picture might consist of.
➤➤

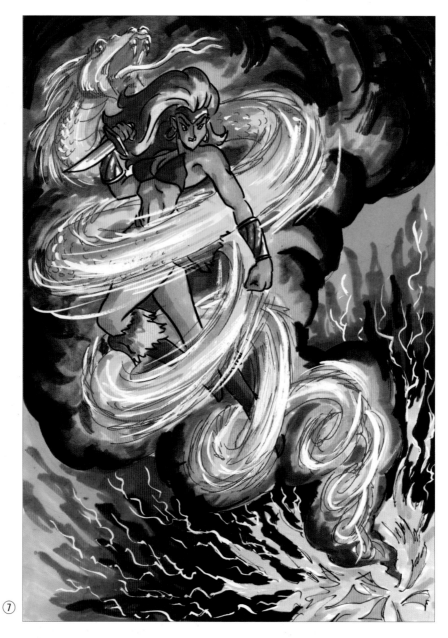

⑦

⑧

⑦ **Color rough**

In some manga stories, characters are imbued with the spirits of wild animals. This seems appropriate for our warrior woman. I'm imagining a snake coiling up through the picture around the figure—this could look dramatic and also reinforce the movement. Taking the rough design I came up with for a background, I

then dashed off a quick sketch and added color to the tones that I had decided on in the last picture. The colors should be as bold as possible —clashing, even. Since this is not intended to be a subtle picture, I've actually used all the colors of the spectrum: warm colors—reds, yellows, and oranges—for the figure and snake, leaving the cool

colors—greens and blues—in the background. This separates the warrior and her snake spirit from the rest of the picture, distancing them from the area below. Since this was only a rough sketch, the lines of my snake are very scratchy, but I like the effect—they add a little raggedness and swirl to the creature. They could work well in my final artwork.

⑧ **Line drawing of background**

Before computers were invented, an artist would draw an entire picture (objects plus background) all at once, then color it by hand using watercolors, colored inks, or a mixture of different media. But now that we have computers, there's no need for me to draw and color the warrior woman that I've already created. I'll finish the background first, then drop her on later. For my precise drawing of the background here, I started with a pencil sketch, then went over it in black line.

▶▶

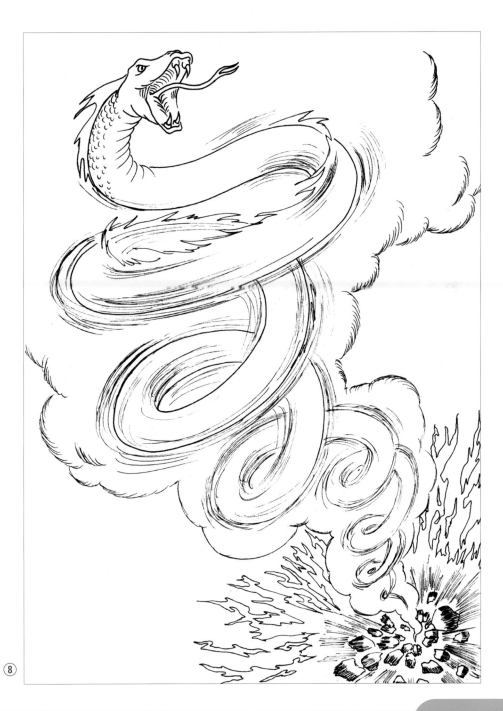

⑧

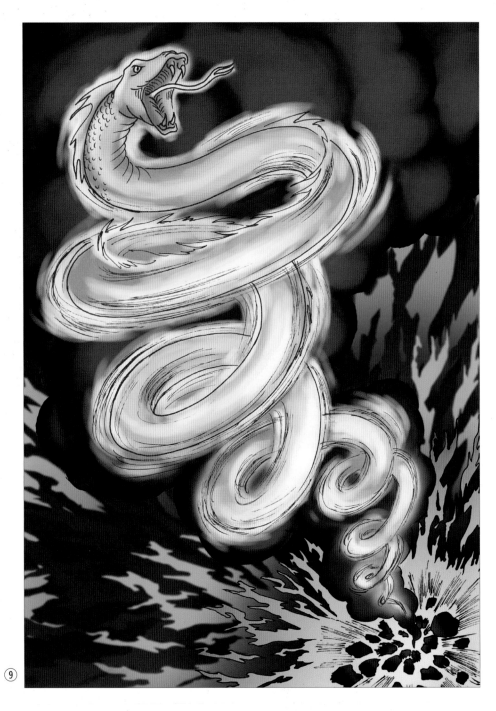

⑨

《《

⑨ Color background

I scanned in my black line drawing and then erased any grubby marks before applying the color and digital effects. (There's a lesson in computer coloring on pages 91–94.)

Completed artwork

When adding the figure I had to erase parts of her body so that she appears to be encircled by the snake. Compare the finish of this computer-colored picture to my color rough.

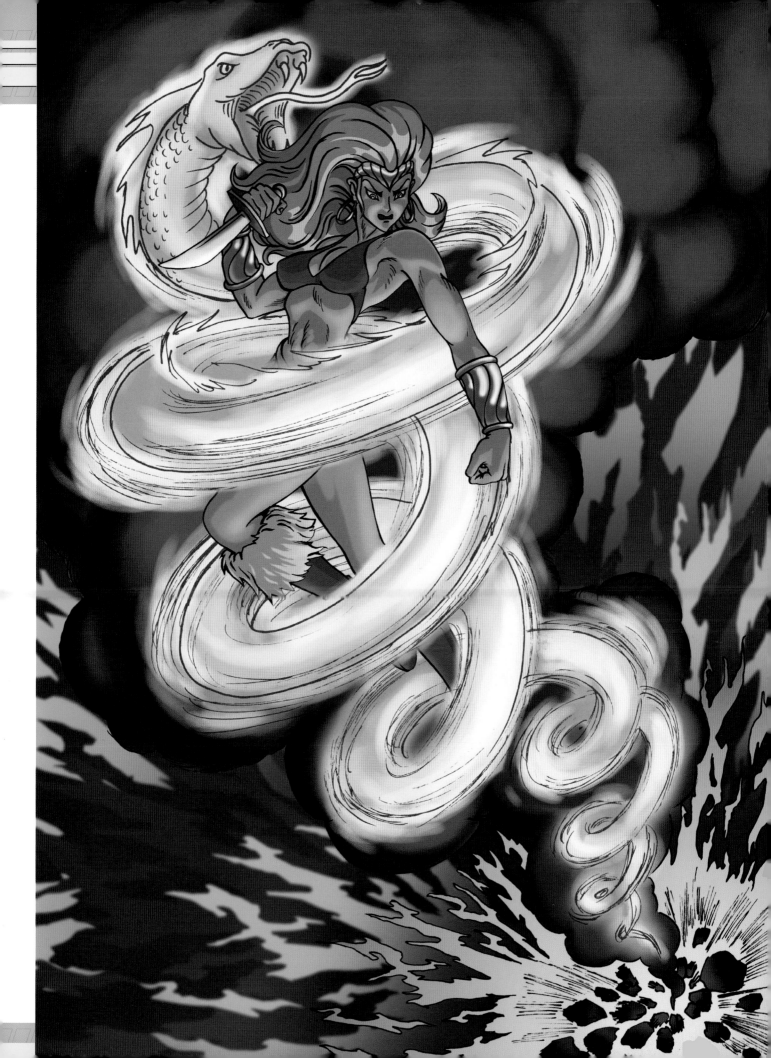

Horizons

When you look out over a flat landscape, there will always be a line where the land meets the sky—this is the horizon. Understanding a little about how the horizon works in relation to pictures will help you design convincing background scenes and place your characters against them accurately.

① Eye level

The horizon of a picture represents the eye level of the viewer. In this diagram, we (the viewers) are exactly level with Duke—his eye level is at the same height as ours so it rests on the horizon line. No matter how near or far from us Duke may be, his eye level remains the same—level with the horizon.

② Low eye level

Now imagine that you are lying on the floor looking up at Duke. Because your eye level is lower, Duke is no longer level, but towering above you. The horizon here runs level with his ankles, and once again, this remains constant no matter how far or near he may be.

③ Different characters

Your manga characters are not, of course, all going to be the same height. Here we're back level with Duke, but as you can see, Magnus is taller and so is higher than our eye level or the horizon. Since Daisy is shorter than Duke, she is lower than our eye level or the horizon.

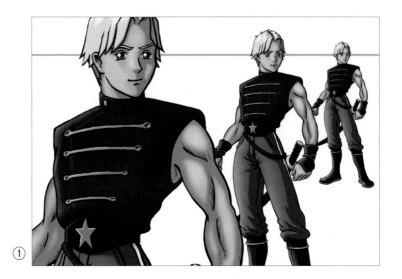

①

②

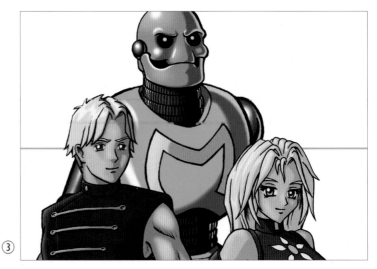

③

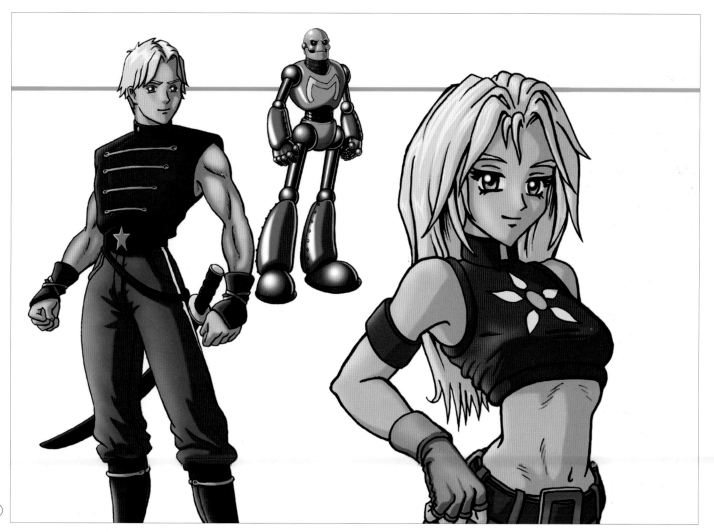

④

⑤

④ **Distance**

As before, the distance of these characters from the viewer doesn't affect their height above or below the horizon. The horizon still runs through Magnus's chest and near the top of Daisy's head, just as it did in the previous diagram.

⑤ **The team**

Here's the team again but this time seen from a lower eye level, as if the viewer is sitting on the floor.

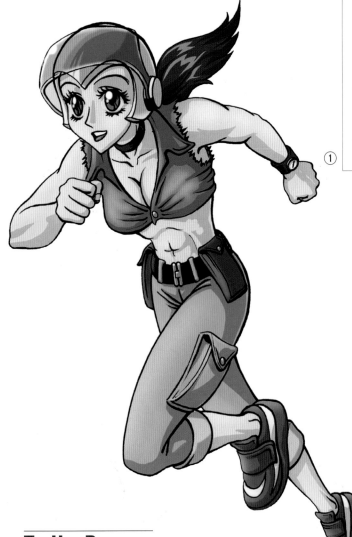

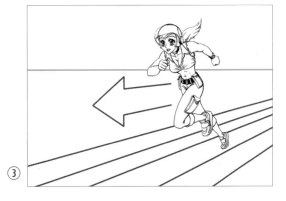

To the Rescue

Our biker girl, Revvy, is clearly running along a ground plane. This gives us the opportunity to put into practice some of what we've already learnt about horizons. The background should be based on the real world and set in the sort of place where danger is never far away. There should be enough in the scene to inspire the viewer to imagine what sort of action is about to occur.

From the way Revvy is dressed, she's obviously somewhere warm. She clearly travels by motorcycle, which would allow her to cover a lot of ground, so I'm going to set the picture in a desert region.

① Bad placement

Placing the figure here is not quite right for this scene—the large space to the right of the figure implies that she is running away from something, which isn't the impression we are trying to give.

② Good placement

With more space to the left of the figure, there's room for her to move into, suggesting that she's running toward something.

③ Direction

I've opted for quite a high horizon and placed the horizon line just over a third of the way down the page. This allows space to show the ground and rocks. The direction lines, marked in blue, show the route Revvy is going to take as she runs through the picture, so I'll be thinking about that direction as I continue to sketch the background.

④ **Background tones**

After trying out different options on scrap paper, I arrived at this rough arrangement for the background shapes. The girl has a clear route through the scene but there is also a clear view of the horizon behind her, giving the setting depth and interest. I've been careful not to clutter the area around the figure.

⑤ **Color rough**

Armed with some photographs of desert scenes, I've added some color and detail to my rough design. The color scheme is harmonious, with mainly yellows and blues, and mixtures of them to make green for some parts. Other colors are in the background too, but nothing so bright that it jars with the overall scheme. I've also added a desert cat at Revvy's side.

⑥ **Line drawing of background**

Now that I know what I want to do, I draw the outline of all the background objects more carefully and go over them in black line. I've created different textures by varying the lines. Rocks are made with rough heavy lines, while the lines of the cacti are more wobbly. In contrast, the skull is smooth and the cat has hints of fur. Objects in the foreground are drawn with heavy lines, which become finer as the features recede into the distance, helping to give the picture depth. ➤➤

④
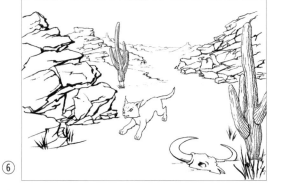

⑤
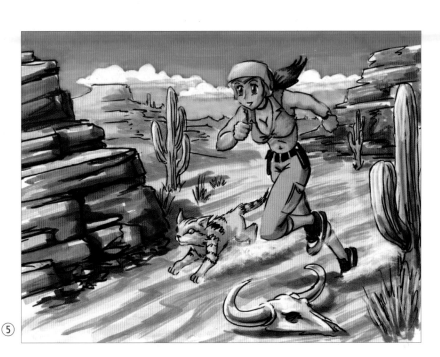

⑥
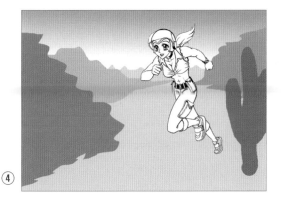

«

⑦ Color background

Looking at my color rough, I can see the scene looks quite light and airy. I want a sense of heat and oppressiveness. I decide to leave out the clouds and also make the coloring of the rocks more dense.

Completed artwork

When putting figures into a background it's important to think about the shadows they may cast. I put a dark patch at Revvy's feet to tie her into the picture. The dust kicking up from her heels also helps.

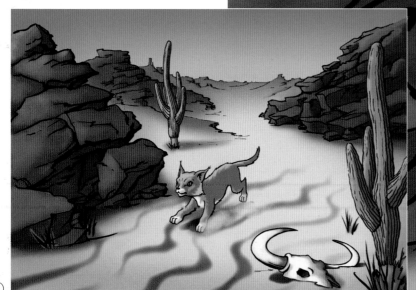

⑦

To the Rescue

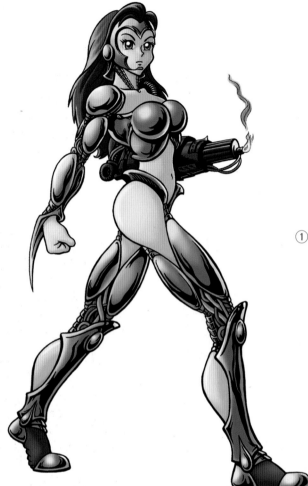

①

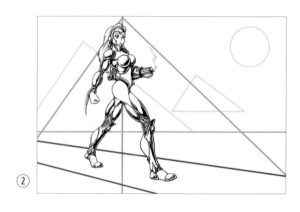

②

Spaceport Boardwalk

This cyborg girl is half-human, half-robot. Her character demands a background that echoes the high-tech and organic mix of her styling. She would clearly fit in a future or alien world. She is striding with a purpose but has no sense of urgency, so we need not concern ourselves with conveying too much movement in the background—we can concentrate on creating a backdrop that suits her elegant poise.

① Placement

Like the biker girl on the previous page, this cyborg needs a space to move into. I'm therefore going to place her toward the left of the picture so she has space in front of her. I think a lower horizon than I used for the biker girl would work well here—showing the character from a low eye level will give her an imposing presence in the picture.

② Geometry

The blue lines indicate the route the cyborg will take. I've made a subtle change to the original pose, slightly altering her left leg so it appears she is walking toward the front of the picture, rather than directly across the page. There's something sturdy and triangular about her pose and position on the page, so I think I could base a strong composition on that idea. Thinking about picture-making in terms of geometrical shapes can often inspire interesting compositions. To enforce the girl's triangular shape, I've added more triangles for background shapes. Although the girl's pose is rigid and upright, her body is quite rounded. A circular sun or moon might work well to soften the angularity of the background. The triangles could be mountains, pyramids, or spacecraft—just about anything. The next step is to decide on a theme.

③ **Color rough**

The cyborg's body suggests the armor of a medieval knight. This made me think of castles and city walls, and gave me the idea of creating a futuristic version of a medieval landscape. But instead of drawing ancient cities surrounded by water-filled moats crossed by drawbridges, I imagined these cities surrounded by the void of space, with jetties stretching out to spaceships. The cyborg is walking along one of these jetties. Although in my scene we do not see where she is crossing from or to, the background features provide enough information for the viewer to imagine the details that lie beyond the edges of our picture.
>>

③

«

④ **Pencil sketch of background**

From my rough color composition I decided to move the foreground jetty up slightly so that I can include more of the deep space underneath. It was also clear that the cities needed to be drawn in more detail. I thought about including other medieval features and came up with the idea of using the shapes of chess pieces for the design of some of the buildings. No material can compete with pencil on paper for working up this kind of design. Start with a hard pencil for sketching in the broad shapes, then gradually add the individual features. Switch to a softer pencil as you home in on details. Always keep your eraser handy— you're bound to need it.

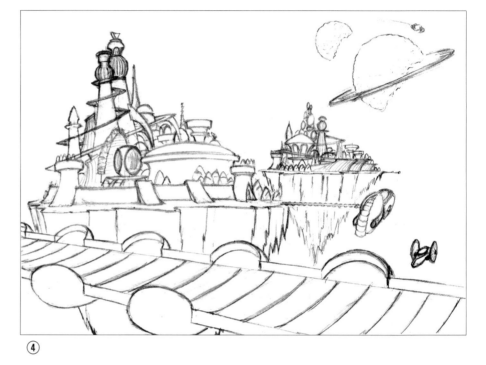

④

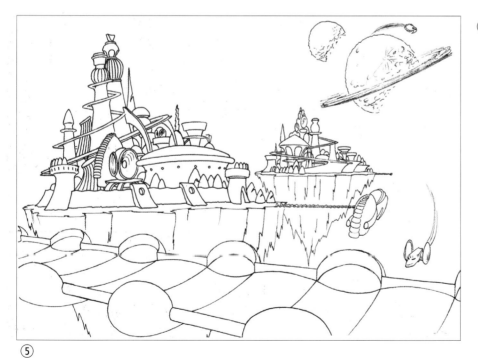

⑤

⑤ **Simple line drawing**

All sorts of materials and tools can be used for inking—from fine brushes, flexible-tip dip pens, and felt-tip pens to rulers, compasses, and ellipse templates. Different types of pictures demand different approaches. Here I've used a single, black fine-tipped pen to go over all the features to clarify the rougher pencil lines. Then when the ink was dry, I erased all the scruffy pencil marks to leave a simple black line drawing

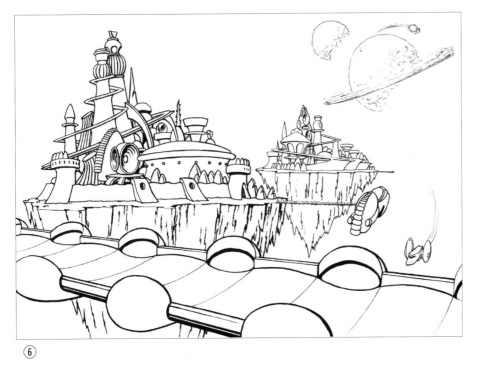

⑥

⑥ Full line drawing

Here I want to demonstrate the difference that careful inking can make. Compare this picture with the previous one. Think of it as consisting of four layers of depth. As in the desert scene, the closer an object is to the foreground, the more dense the line should be. I'm also conscious of the light source. The cyborg is lit from above left, so to reflect this in the background, I've given all the features thicker lines on the side that faces away from the direction of this light source. I chose to draw everything freehand. Precise line work is important for some pictures. For this one, I want to avoid it looking too slick and technical.

⑦ Color background

Consistent with the shading of the figure, I've gone for some fairly high tonal contrasts, as you would expect to see in deep space. The color range is essentially green, blue and yellow with some pink and orange borrowed from the figure to add richness. Shading each of the buildings took hours. Sometimes you have to accept that certain pictures need a lot more time spent on them than others. All that remains now is for the cyborg and her shadow to be put in place.

Turn over to see the completed artwork.

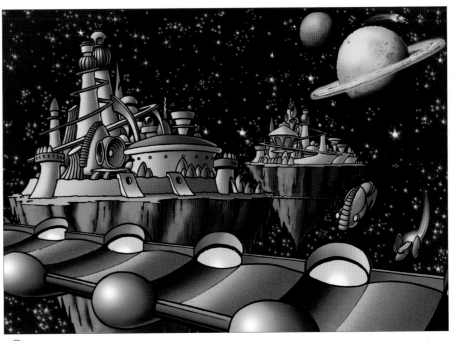

⑦

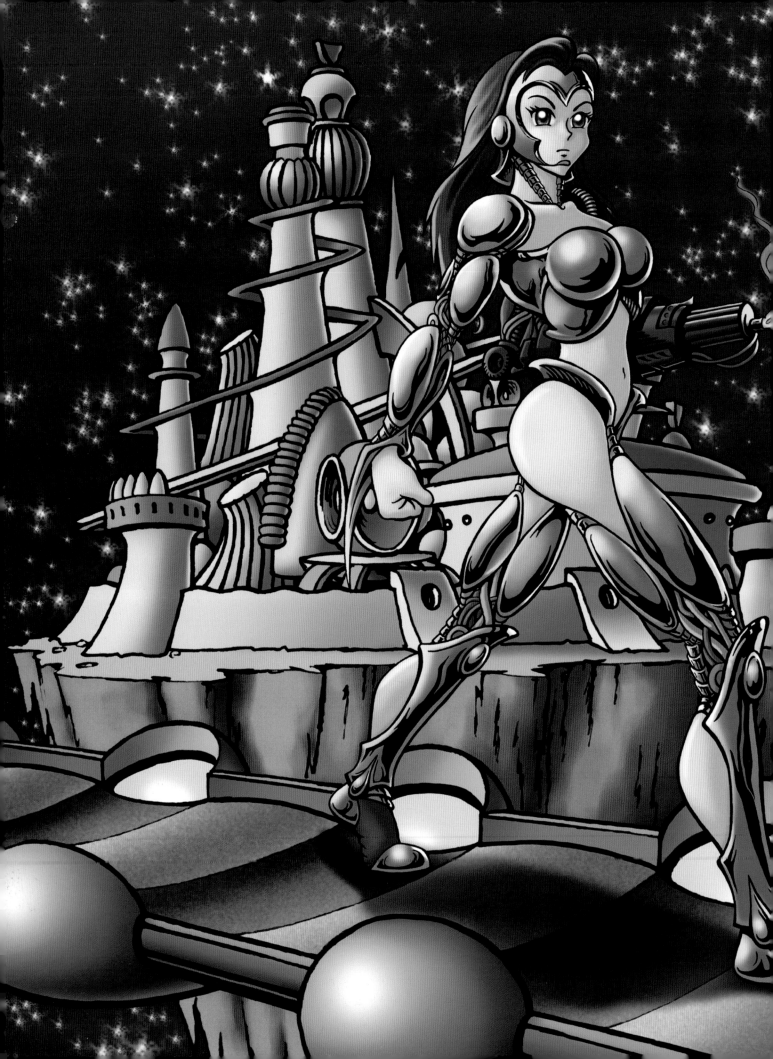

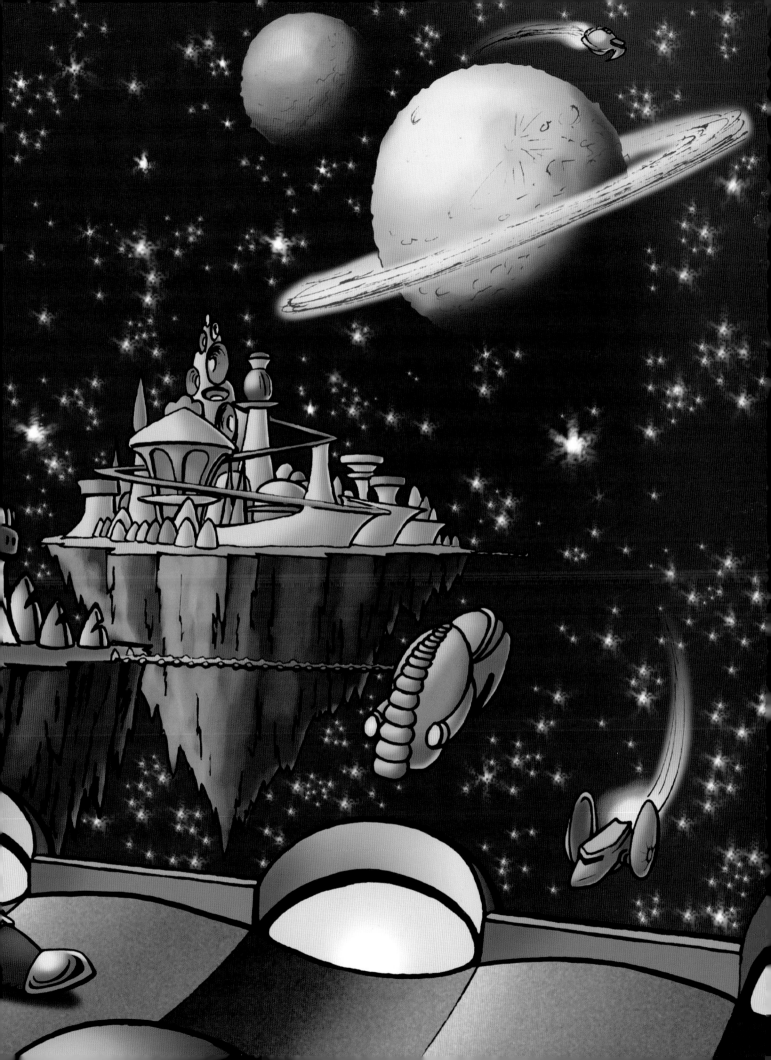

Gothic Nightmare

To demonstrate the dramatic effects of light and shade in a picture, I am going to use this werewolf. It's the dead of night and something is prowling in the shadows, hungry for the taste of blood. We therefore need a setting that conjures up the gloom and atmosphere of a horror story and shows our werewolf at his most threatening. A graveyard scene fits the bill perfectly.

① **Placement**

I'm breaking away from convention again by placing the figure in the center of the picture because I want the focal point to be his wild, glowing eye of the beast. I've placed this on the intersection of horizontal and vertical golden section divisions (see page 11 for an explanation of this). I'm keeping the figure quite small since I want him to blend in with the background and not appear too obvious in the picture.

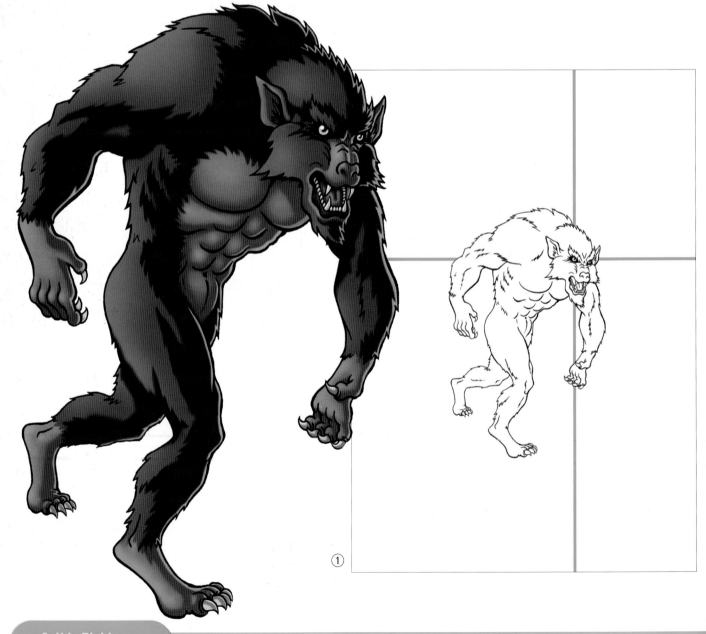

①

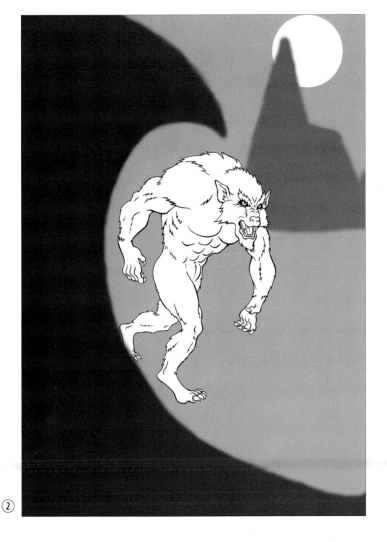

②

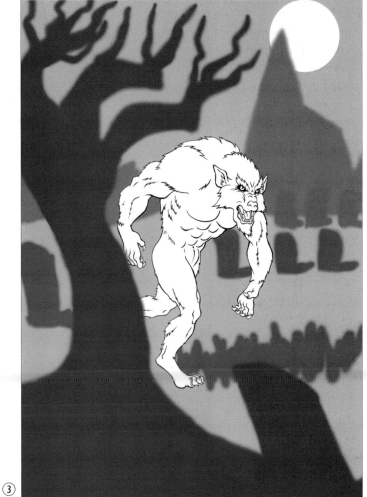

③

② Basic shapes

The lumbering swagger of the werewolf suggests to me that an informal, irregular composition might be appropriate. I'm hoping to envelop the werewolf within the composition, concealing him and hopefully adding to the sinister atmosphere. A curve in the foreground leads the viewer's eye straight to the werewolf's glowing eye. This curve also frames the creature, echoing his hunched stance,

and suggests a path for him to follow on his midnight prowl. The rough shape of a building in the background contrasts with the dark curve in the foreground. Without this building, the picture would seem unbalanced and too heavy toward the bottom left.

③ Final tones

I had originally imagined that I'd turn the dark curve of the foreground shape into some kind of foliage. I

then decided that such a mass of darkness would be too heavy, and opted instead to include a creepy-looking bare-branched tree. Dotting some rough gravestones around helps me think about how to make the lights and darks work in the middle ground. A darker gravestone in the foreground adds to the feeling of rambling clutter I want to convey.
➤➤

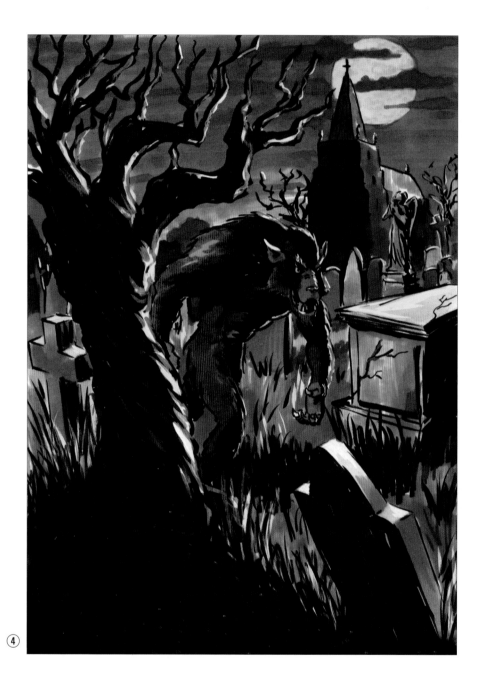

④

<<

④ **Color rough**

The elements of this scene are relatively straightforward to draw—it's all about light and dark masses. With the moon in its current position, the direction of the light should mean that everything is a silhouette. I put the full moon in since it's important to the concept of the werewolf, but I worked taking into account another unspecified light source coming from the upper left and used the moon as a secondary light source. This is technically known as cheating, but it's an effect that you see in manga a great deal—a spot of back lighting like this helps add creepy-looking highlights around the edge of shadowy characters. At night, when the lighting is dull, color becomes very muted and indistinct. For this reason, I've kept the color range very limited, using more black and gray than any other color.

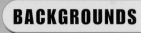

⑤

⑤ Background in black line

There's no point in doing a detailed pencil drawing for this kind of scene. It's as effective—and more fun—to just use a pencil for roughing in the basics of the features, then getting right down to drawing the spindly branches and the blades of grass with brush and ink. I took a little more time over drawing the tomb stones and church, but the great thing about scenes like this is that nothing has to be very precise— wobbly and rough lines help create the look of gnarled wood and old stone.

>>

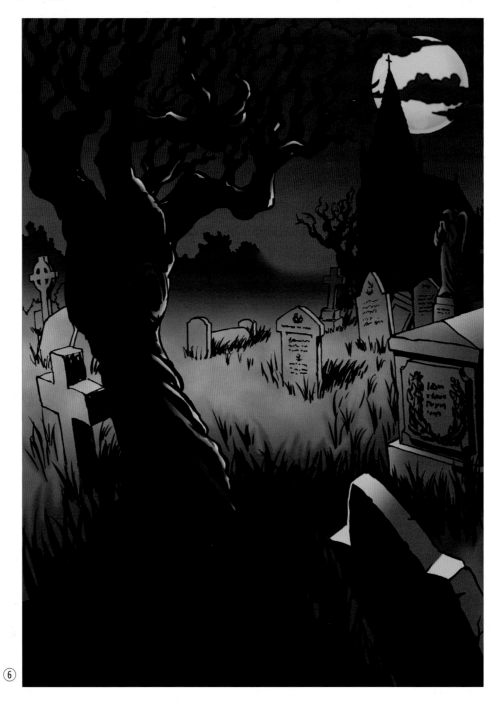

⑥

<<

⑥ **Full color background**
Having done all my working out in my color rough, coloring this background was a very simple task. Unfortunately not all my rough marks with felt tips were reproducible by computer.

Completed artwork
The tree overlapping the werewolf and the similarity of coloring serve to unite the werewolf with his environment. Quite simply he belongs in this scene.

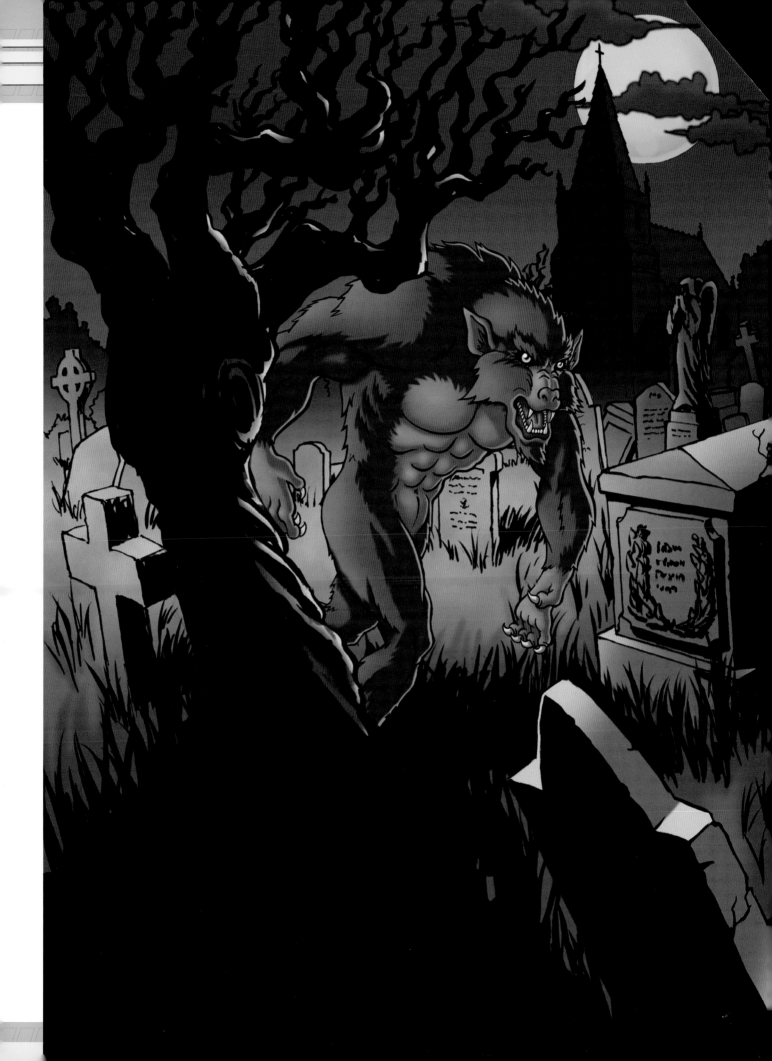

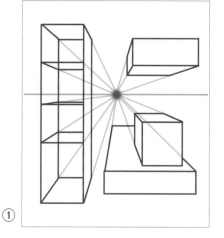

①

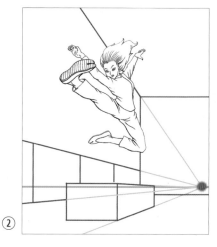

②

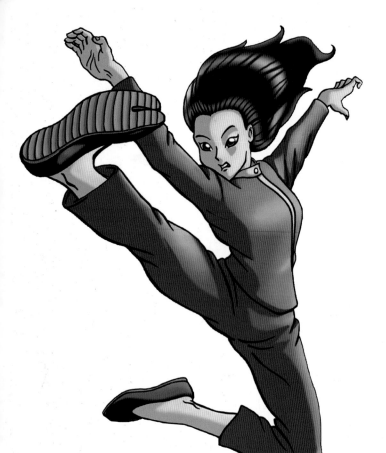

Kung Fu

The setting for this character, Jenna, should be appropriate to her manner of dress, which is traditional Japanese. The composition should also make the most of her dynamic flying kick pose and suit the exaggerated foreshortening.

Perspective

I'm going to set this picture inside a building. I'm hoping this will provide an intriguing contrast to the action of the figure. To make sense of all the angles of a room, we have to know the rules of perspective. We already touched on this when we looked at different levels of horizon, but now we'll take it a stage further and explain what you need to know to draw buildings.

① The setting

Most buildings are constructed of right angles—floors are level, walls strictly vertical. That fact makes the perspective of a building quite simple. Here we see a number of boxes drawn to look three-dimensional, and to show us one-point perspective—all the horizontal lines pointing away from the viewer converge at a single point on the horizon regardless of whether the box is above or below it. The point at which these lines converge is called the vanishing point (marked in red). From this angle, all other lines of the boxes remain vertical or horizontal. Let's see this in practice.

② Rough composition

After trying out a few variations as thumbnails, I arrived at this rough arrangement for the elements of my picture. I'm not too concerned with a precise composition at this stage because I want to get the perspective sorted out first. The idea is to use the perspective of the room to lend direction and impact to the figure. I constructed a room to match the perspective of the girl. To create a sense of her height above the ground, I chose a low horizon and placed an object (just a plain box at this stage) beneath her.

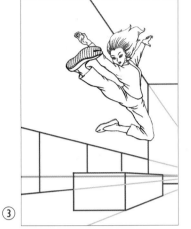

③

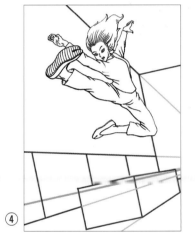

④

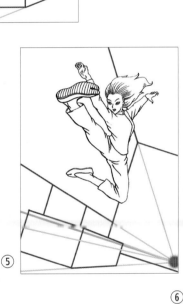

⑤

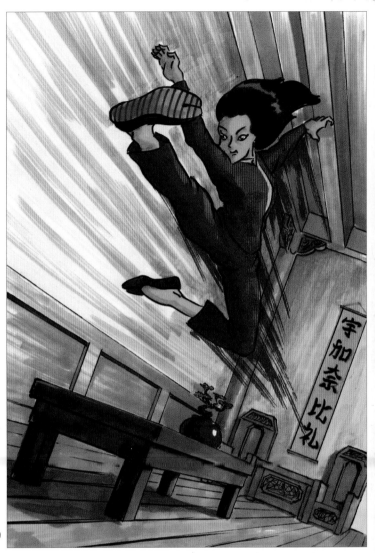

⑥

③ Refined composition

Once the environment is established, I can concentrate on making the picture work compositionally. Here I've simply cropped off the right-hand edge—this immediately makes the picture more balanced. I still think it can be improved, though.

④-⑤ Skewing the picture frame

A common device used in manga is to skew the frame of a picture. This creates tension and breaks up the monotony of vertical and horizontal lines. By twisting the same picture around within the frame, different compositions arise, each of which affects the dynamics of the picture. Picture 4 is more visually interesting than picture 3, but it still doesn't quite work. The girl seems to be falling rather than leaping upward. My second attempt (picture 5) works much better. Jenna really seems to be exploding across the room.

⑥ Color rough

Traditional Japanese interiors are usually quite minimalist. A few simple objects and decorations, and a restrained and harmonious color scheme are all that is needed to conjure up an authentic atmosphere. Against this backdrop, Jenna's vivid red suit makes quite a splash. I deliberately kept the area around her quite empty—to allow space to trail some movement lines behind her. Since the girl is moving in line with the room's perspective, these movement lines should lead to the same vanishing point.

»

⑦

⑧

«

⑦ Background in black line

This drawing is not quite as simple as it looks. The skewed angle is disorientating when drawing the verticals and horizontals. I used a set square constantly to keep checking right angles, like the ones made by the top and legs of the table. I also used a ruler to ink all the straight lines—appropriate to the clean lines of Japanese interiors. For the kanji script on the wall, I used a Japanese brush pen to create the right feel.

⑧ Color background

Computer coloring is very well suited to the smooth, flat surface of this room. Rooms are usually darker toward the corners, so I've put some shading on the walls. I also decided to break up the plain floor surface with some reflections of the furniture.

Completed artwork

Because of the action of the figure, adding her to the background was quite a complicated job. The speed-lines in front of her show up well against the plain wall. Behind the figure I went for a more sophisticated effect, tracing Jenna's path with diminishing 'ghost' images.

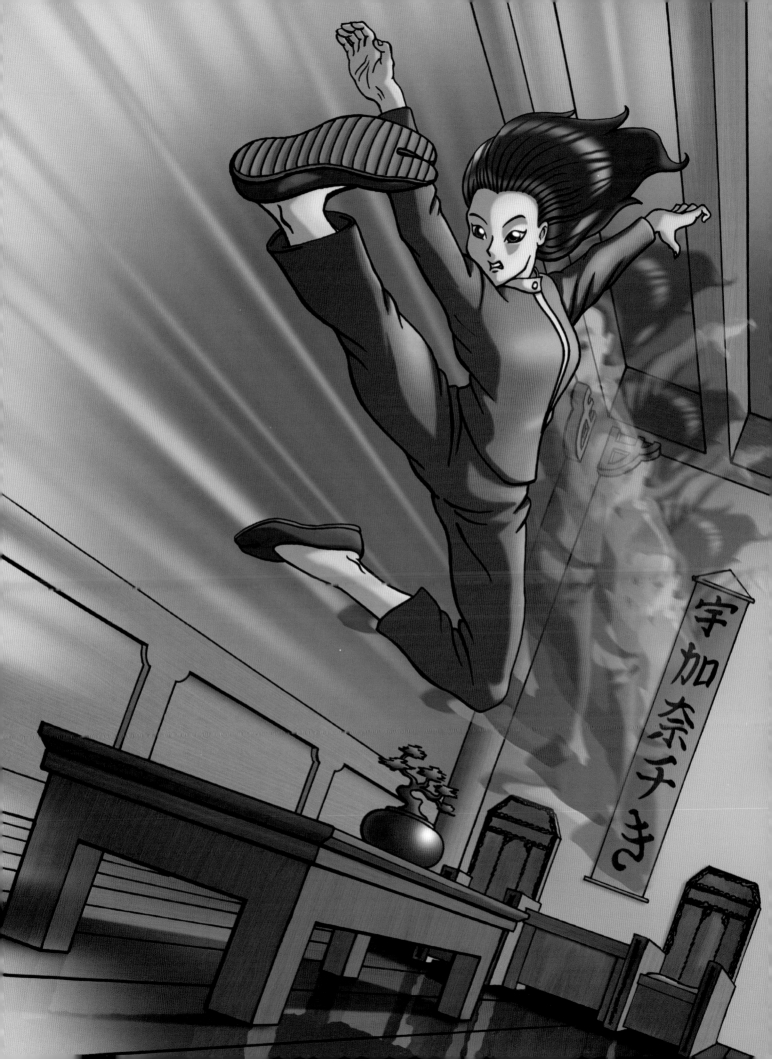

Robot Rampage

A character like our giant robot needs to be placed in a large-scale setting, and to be amongst objects where it looks like he could do some serious damage. A big-city scene would be a good backdrop. The challenge would be to drop him in among the skyscrapers and suggest impending havoc.

① **Composition**
Out of a whole batch of thumbnail drawings, I chose this rough composition. The perspective of the figure is such that his eyes are level with the viewer's. I've therefore placed the eyes on the top-right golden section division, level with the horizon. This gives the robot plenty of space to swing his mighty arm. I'm treating the perspective of the buildings as simple blocks at this stage. Here I just need to work out the size and placement of the broad masses. I'm imagining the robot hemmed in, as if he's fighting his way out. In all good stories, there should be tension, so it shouldn't be obvious who is going to win this battle. I want to present the robot as being under heavy attack. The helicopter alone doesn't pose much of a threat, so when I draw the background, I'm going to introduce a couple of fighter planes. I've left space in the composition for them—the blue arrows indicate their direction through this space.

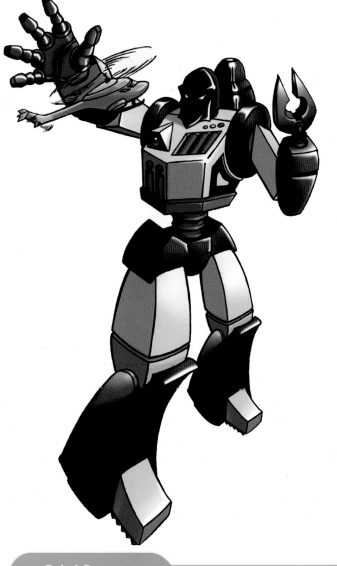

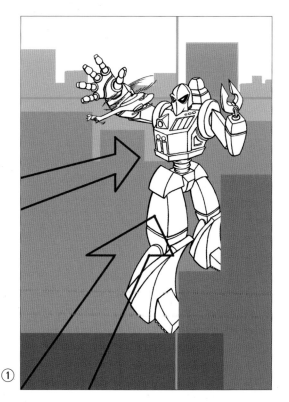

①

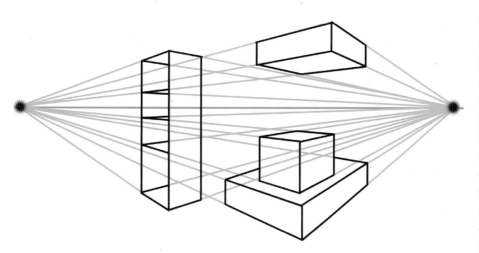

Two-point perspective

Here's the same set of blocks we saw on page 48 from a different angle. In this diagram the lines of the horizontal edges of the blocks now also converge at a second vanishing point farther along the horizon. It helps, though, that all the lines of the vertical edges remain rigidly vertical wherever the blocks are placed in the picture. The best way to understand this principle is to see it in action, so we'll now apply it to drawing a background for our giant robot.

Background in perspective

Working from my rough composition, I have redrawn the main blocks more precisely and in perspective. For a drawing like this you need to mark the horizon (green line) and the vanishing points. The easiest way is to work on a desk and fix the paper with masking tape. Then, using a soft pencil, position the vanishing points off the edges of the paper, directly on your desk—if you don't press too hard, the pencil marks should rub off easily later. Using a hard pencil, lightly block in the main shapes. When they are close to what you want, take a long ruler and use your softer pencil to line up the edges of the buildings so their lines meet at your vanishing points. I've used two different colors to show these lines. Remember: 1, vertical edges should remain vertical and parallel to each other; and 2, the horizon is the lowest point of the sky—objects may cross the horizon and reach into the sky, but the sky never falls below the horizon.

Once the main blocks of your drawing are in place, leave your piece of paper where it is—you'll find the vanishing points invaluable for drawing all the tiny details later.

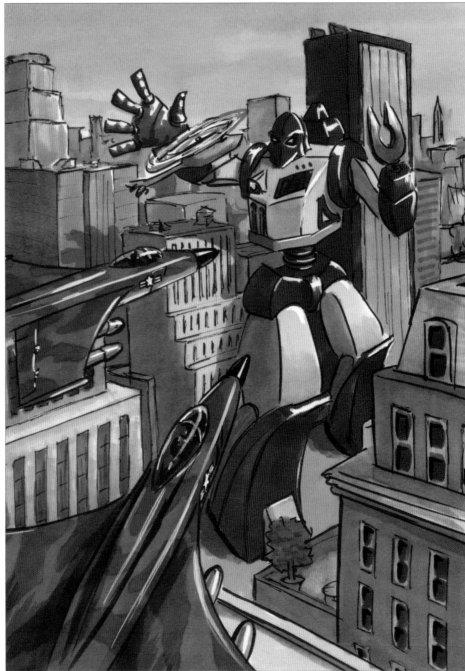

②

② **Color rough**

I drew this rough sketch straight out of my head. The perspective isn't perfect, but it's close enough for the purpose of trying out my composition. As for the color, I've kept the palette restricted to dull browns, grays, greens and blues to give the scenery a naturalistic feel. The bold red of the robot stands out nicely against them. The tones and colors are stronger in the foreground and become weaker the farther away they are in the distance. The term for this effect is aerial perspective.

>>

③ Background in black line

Creating a precise and detailed line drawing takes time—this one took me about 12 hours! There's a lot of careful ruling, measuring and double checking along the way. Make sure you don't completely cover the page in detail—the picture needs some empty space or it will look cluttered.

Ink all the lines with a ruler, still lining them up with those vanishing points, then erase the pencil guidelines that you will have built up.

④ Line drawings of planes

These are the line drawings of the airplanes that I will scan into my computer, color separately then place on top of the background. I haven't included much detail in them, because I plan to blur them for a sense of speed.

③-④

Having the luxury of a computer for the final coloring means I'm free to keep some elements separate from my background artwork. This is absolutely essential for animation but also useful for creating an individual piece. It means that the positioning of all the elements can be adjusted right up to the final stage.

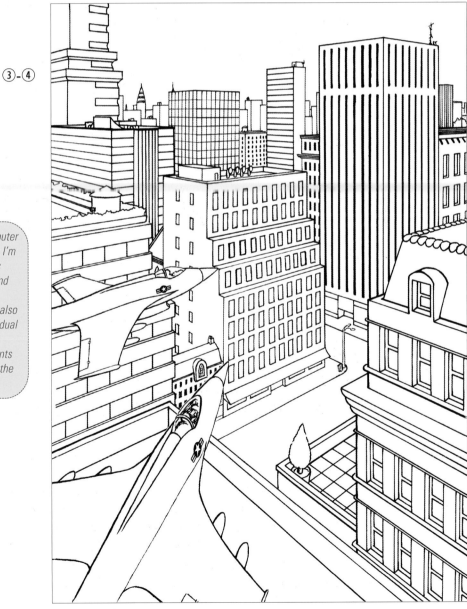

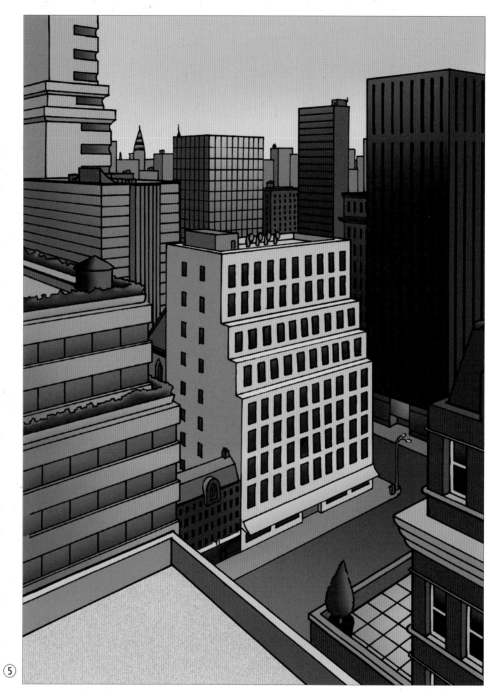

⑤

《《

⑤ **Full color background**

With quite simple shading and coloring, I've gone for broad areas of flat color and tone, enough to show the solidity of the buildings but not to clash with the detail of the linework.

Completed artwork

Having parts of the robot obscured by foreground elements instantly places him in the scene. The planes are rendered in the same simple style as the buildings.

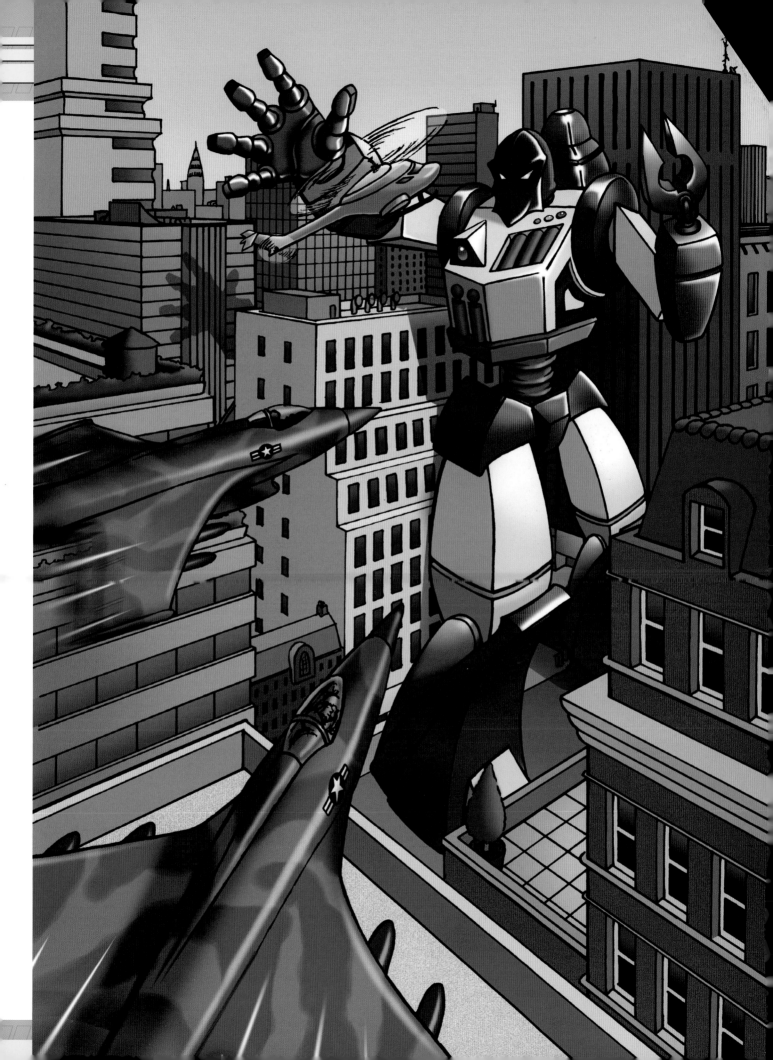

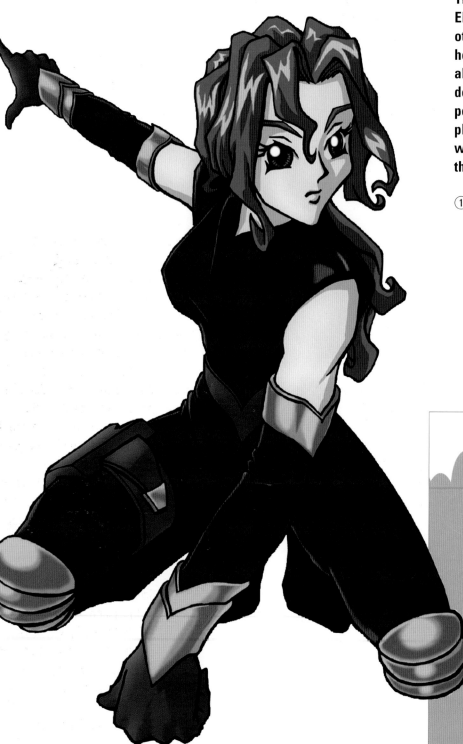

City of the Future

The challenge is to put our character, Elise, in a setting that suits her other-worldly look and makes use of her complicated pose and gesture. I also want to use this picture to demonstrate yet more complex perspective. I'm therefore going to place her above a futuristic cityscape with strange buildings stretching to the horizon.

① Composition

This figure will fit neatly into a composition similar to that of the giant robot picture. But Elise needs a reason to be placed above the scene. Some sort of high-tech hovering surfboard might be fun. I've marked the rough position and scale of this as a dark ellipse.

①

Three-point perspective

One of the defining characteristics of manga is impressive perspective drawing. So far, we've looked at one- and two-point perspective and also touched on aerial perspective. Now we'll look at three-point perspective.

When a picture features objects that sit far above or below the viewer, an extra vanishing point is needed. In this diagram all the lines that remained vertical in the two-point perspective diagram (see page 53) now slope and converge on a higher vanishing point. This creates the impression that we are close to the boxes and looking steeply up at them from a low viewpoint.

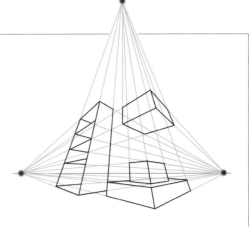

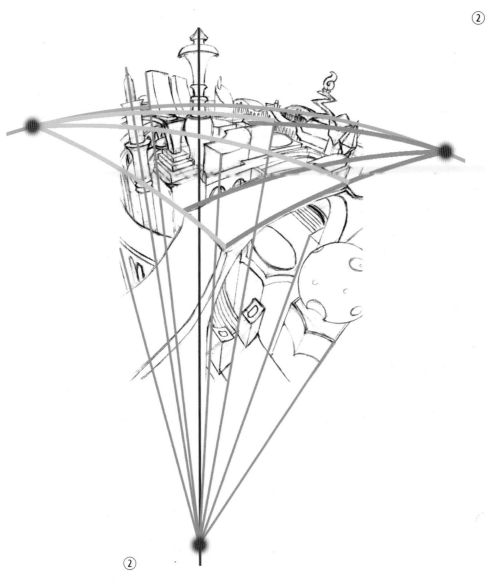

②

② Background in perspective

Here's a pencil drawing of the background I came up with—I'll show you this in more detail on the next page. This drawing shows the main blocks of the buildings. I had in mind the concept of a world where every bit of land is built on, rising ever higher to accommodate an escalating population. To convey this idea of a small planet I want to show the curvature of the surface so I made the horizon curve, as shown by the green line. This means that all the lines of perspective running to either of the horizon's vanishing points have to bend too (blue and purple lines). This also has the effect of emphasizing the depth of the third perspective point—this is deep below the horizon because we are looking down on the scene. All 'verticals' converge on the third perspective point (orange lines). There is only one vertical line in the whole picture, running directly up from the vanishing point. The tallest tower sits directly on this vertical line for maximum impact.

>>

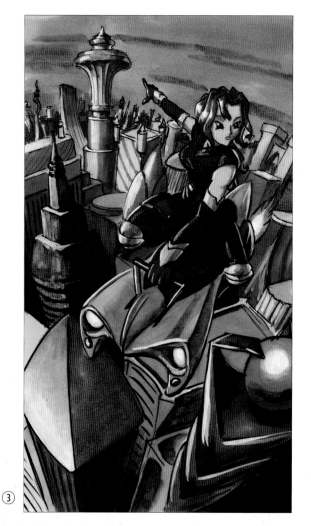

③

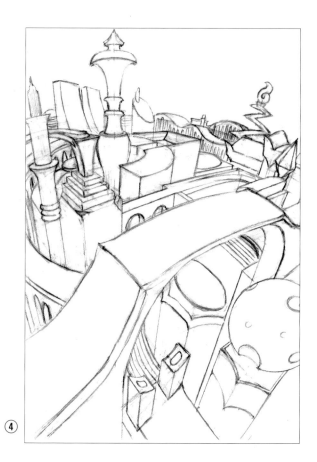

④

«

③ Rough color sketch

Rough color sketches can be very helpful to find out which elements do and don't work in a composition. I can now see that my original idea for the girl to be crouched on a hovering vehicle doesn't work—the space bike gets lost amongst the chaotic colors and shapes of the background and it does not completely suit the girl's pose. This calls for a rethink. Some things did work well, though. I've used a whole range of clashing colors to add to the sense of new buildings being squeezed into this city at random over the years. Cropping off the edges of the picture to make a taller format suits the nature of the buildings and emphasizes their height. There is no doubt about the focus of the girl's interest—she is pointing to a mysterious tower.

④ Pencil sketch of background

Before you apply color, a scene like this must stand up as a line drawing. Referring to my color rough, I have redrafted my picture in pencil on decent paper, keeping the elements I liked and changing those that I was less pleased with. The flying surfboard has been replaced with a bridge structure between two buildings. The building forms here have come straight out of my head. I'm redesigning them because those of the color rough appear too bland and blocky, and I need to accommodate the new bridge. Even though I expect to crop the edges, I include detail at the sides so that I can decide on the eventual format later on.

⑤ Simple black line

Once I worked out the basic shapes and perspective in pencil, I went over my final pencil lines in black ink to make a simple line drawing. I added some bits of detail as I went, then erased all my rough pencil lines.

⑥ Final inking

Next I added the last details to my picture. I then worked over the line, smoothing out the curves and increasing the weight of the line work in the foreground. Finally I took another look at all the parts of the picture to make sure that all the buildings were clearly defined, strengthening the lines where necessary.

»

⑤

⑥

As an artist, it's your job to direct the viewer in the reading of your pictures—some questions might be left unanswered, others might be shown as clear as day. What the viewer sees in a second may take you hours to create.

⑦

<<

⑦ **Full color background**

Before applying any color, I worked on the tones of the buildings, keeping each one clearly defined and the lighting consistent. The tones were also important for capturing the eerie twilight feel I wanted.

Completed artwork

With Elise in place, and a shadow put in underneath her, I decided not to crop the sides of the picture. This change of mind ensured that the chaotic sprawl of the cityscape could be retained.

ACTION

Putting a single figure against a background is one thing. Creating a background that works when two characters are interacting in a scene is something else. The composition needs to work for both figures and it must be clear what action has just taken place or what is going to happen next—your pictures shouldn't leave too many questions unanswered.

The colors used for both characters will need to work together with the colors of the background scene.

We'll be applying many of the techniques you've learnt so far too, such as perspective and use of more than one light source, so there may be times when you want to flick back through this book to remind yourself about these aspects of drawing.

Making a scene say what you want it to say can take some planning so we'll also look at how you go about deciding what elements you should include in a picture and what to leave out. Here goes . . .

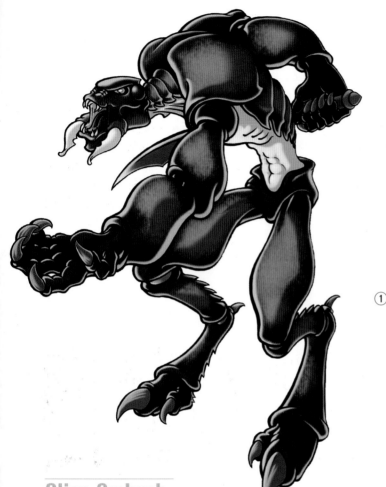

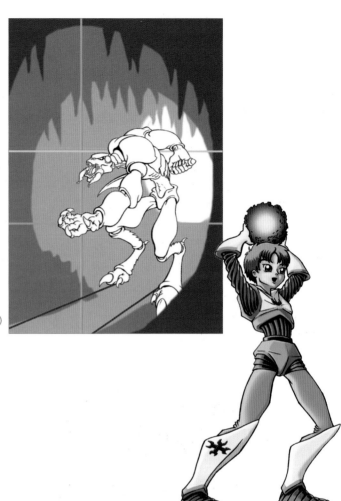

Alien Ambush

I don't think we'll ever come across a character like this in real life, so we'll have to use our imagination to conjure up some suitably unwelcoming environment. I want the scene to look hard, like our alien's body surface, and have something of the angularity of his claws—bizarre rock formations might be just the thing. I want the composition to accentuate his posture and threatening gesture. Lastly, I want to see if those interesting highlights on his body can be incorporated in the scene.

① Composition

By trying out some alien landscapes as thumbnails, I gradually arrived at the idea of an underground setting. Here's the composition I came up with. A succession of curves draws the eye into the depths of the picture, toward a light source behind the alien. The shape of these curves acts as a framing device for the figure and also echoes the stoop of his posture. I've placed him low in the frame to stress the weight of rock and stalactites above. He has a clear route through the picture, marked in blue. To make a feature of his clawed hand, I've placed it at the meeting of

two golden section lines (see page 11 for explanation of this theory). Although there's no visible horizon in this scene, we still need to keep the eye line in mind which is shown here as a paler green line.

② Secondary points of interest

After giving this composition more consideration, I decided that although it works well as an arrangement of shapes, as a picture it's not really telling a story. It needs another element—a secondary center of interest. The addition of space boy Kom could be just what's needed to inject some drama into the scene.

③ **Adding an extra character**

Bringing in Kom has immediately changed the dynamics. Kom is drawn as if we are looking at him from a low eye line, so he needs to be placed high up in the picture—I erased a bit of the rock to fit him in. The curve of the rock formation implies the direction in which he is about to hurl the boulder. Now there's a real sense of a story unfolding—the alien is coming out of the cave after the boy, but has no idea he is about to be ambushed.

④ **Rough color sketch**

I built up the tones bit by bit. Not only must the cave appear to have depth and solidity, but the lighting must be consistent with the scene. There are two light sources here, like in the earlier graveyard scene: a mysterious light behind the alien casting an orange glow on him and on some parts of the rocks, and a more natural light from top left. When using deep shadows, try to construct your picture so that important features are brightly lit

against dark areas and starkly silhouetted features are lit against very bright areas. Less important elements can be closer in tone. Although I'm happy with the tones, I'm uncertain about the color scheme. I don't want the rocks too dull and gray, and yet I don't want the colored light getting lost among too much other color.

≫

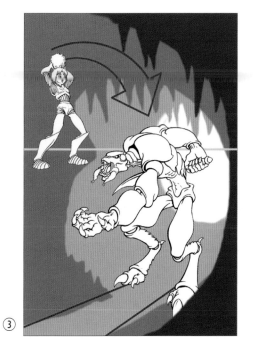

③

④

⑤

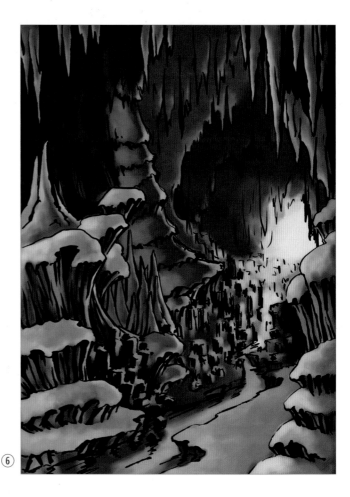

⑥

<<

⑤ **Black line drawing**

For this kind of scene, it is not necessary to make a detailed pencil sketch. I drew a few pencil curves to show the basic shapes, then went to ink and brush. Starting with the foreground rocks and working back, I made progressively lighter marks with each layer of depth. I also varied the brush marks to describe different kinds of rock surfaces, and used solid black for places completely shielded from both light sources.

⑥ **Color background**

This being a very dark picture, I again worked on the light and shade first, darkening the shadow areas bit by bit. Once I was happy with the cave's depth and contrast, I added the colored highlights. Then it was just a case of dabbing on some grays and browns to build up the color and texture of the rock surfaces.

Completed artwork

Because I had kept the colors of the background quite dull, when the figures are added their colors are vibrant in comparison. Against the darkness of the cave interior they really seem to glow, which is an effect I had not predicted. Among the greatest thrills of creating artwork are the happy accidents that can occur along the way—even when using a computer.

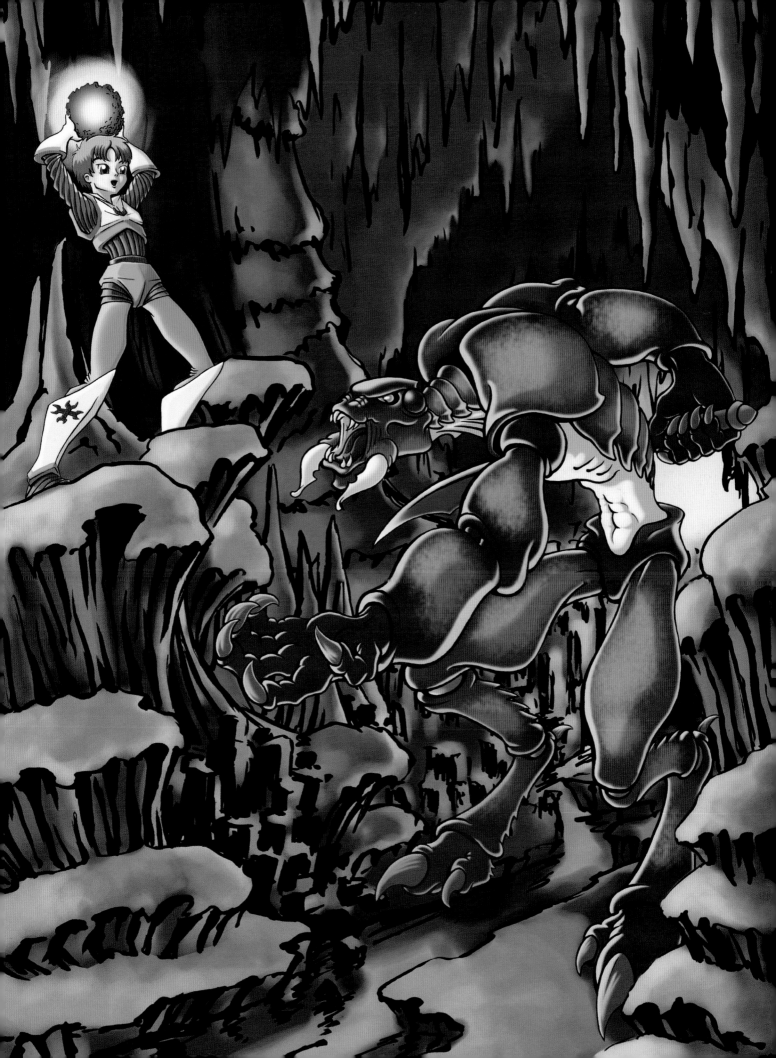

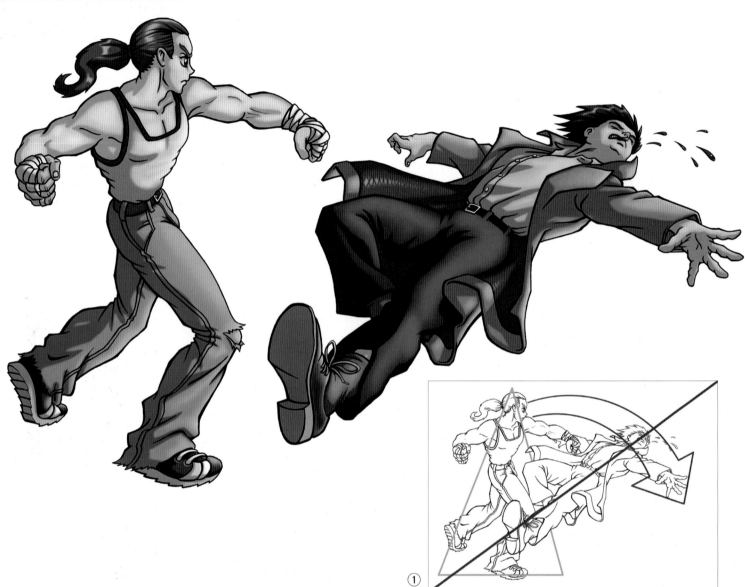

①

Urban Brawl

It's quite obvious what these two are up to, so we need to bring them together in a scene that suits their fistfight. We want a setting that's suitably squalid, like a smoky bar or, even better, a grimy, rat-infested back alley. The composition should complement the action.

① **Dynamics**
The composition doesn't need to be too elaborate because there's so

much dynamism already. Combining figures in close combat means that their bodies may overlap—in our picture Rik's leading fist is in front of Steel's arm and Steel's foot sticks out in front of Rik's right leg. Two distinct motions are at play—Rik is swinging a punch, so all of his movement is in his upper body. His feet are placed firmly on the ground. In compositional terms he is balanced. In contrast, Steel is decidedly

unbalanced and falling at quite a steep angle. This immediately suggests a diagonal composition— where the line of Steel's body follows a diagonal division of the picture (shown by blue line). With most of the action in the top part of the picture, it makes sense to leave the bottom half empty as a space for Steel to fall into (shown by blue arrow).

② Composition

Some kind of foreground object is needed in the empty space at the bottom right-hand corner to balance the action in the upper half of the picture. I've put this in as a random dark shape for now. A large solid mass behind the figures, such as a wall, will present a plain surface to place the action against. I intend to add movement lines, which will stand out against the wall, as will the droplets of blood. I've chosen a shallow one-point perspective—there's plenty of drama going on between the characters without needing the extra impact of steep angles in the background. Rik's perspective indicates a high eye level, which we need to be aware of for adding other elements to the background. After drawing this, I decided that the figures would need just a little more room to move, so when I sketch my color rough, I'll draw them at a reduced size.
»

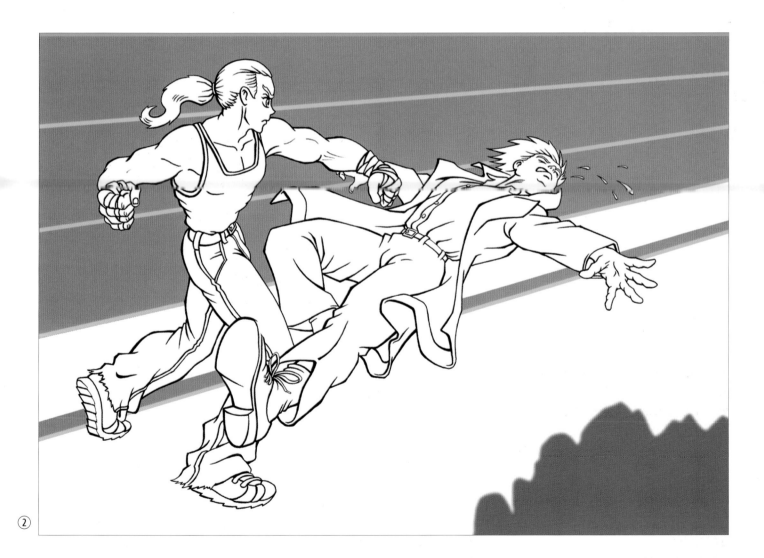

②

Mise-en-scène

When composing a narrative scene like this, we need to consider what to put in the picture. Each element and its effect on the scene needs to be considered individually—adding one small item can make a huge difference to the impact of a scene and what it communicates. Filmmakers and animators call this mise-en-scène.

Scene 1

All we see here is a fight between two men in an alley. We can guess which one is the bad guy—in manga, purple and green are usually associated with villains—but it's only a guess since there's little other information to go on.

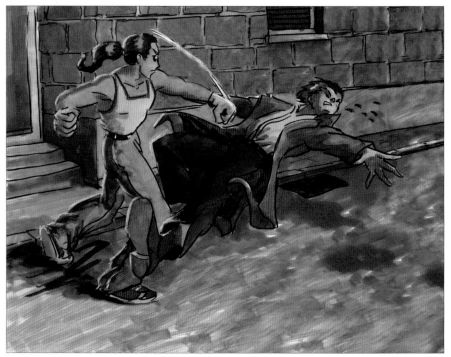

Scene 1

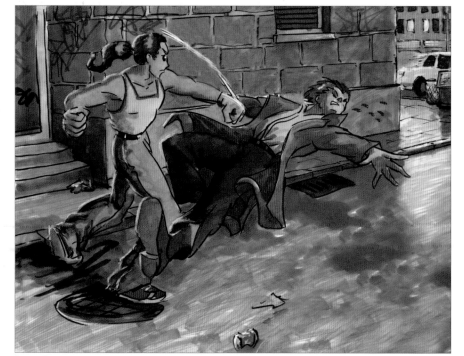

Scene 2

Scene 2

I've brought in the right-hand edge of the building to allow space for a small vignette of life beyond the alley. Adding those few details immediately tells the viewer that the alley is in a big town or city and that it's night-time. These additions also break up that great expanse of brickwork and provide an extra layer of depth to the picture. A few spots of graffiti to the wall helps convey the squalor of the scene, along with some trash scattered about. But the viewer still might want to know more.

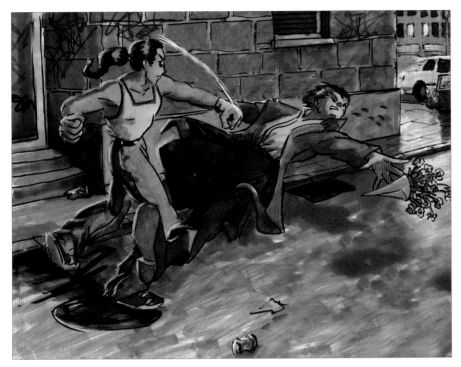

Scene 3

Scene 3

The addition of something as simple as a bunch of flowers can completely alter the interpretation of the scene. Now it looks like the guy throwing the punch is the villain, attacking an entirely innocent man.

Scene 4

Introducing another figure can also change our view of things—the fight doesn't seem so serious when it appears it's for a movie.

>>

Scene 4

<<

③ **Final color rough**

Of course, I don't really want flowers or a camera man in the finished picture. A trash bin and debris are much more suitable for breaking up that empty space and also add to the sense of squalor. Putting a knife in place of the flowers removes any doubt as to which of our characters is the bad guy. I like the way it's heading for the bin—just where it belongs! Now for one last manga touch—a sound effect to lend weight to that punch.

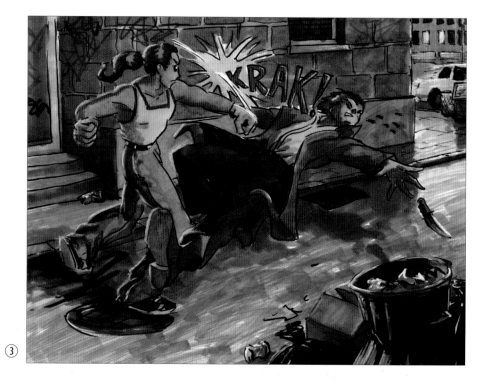

③

④

④ **Line drawing of background**

Inking a scene like this is quite straightforward. The lines should be rough and scruffy, so there's no need to use a ruler. All sorts of rough marks on the wall and floor can add interesting textures and scuffing. Some spots of gum and litter can be liberally scattered about.

⑤ Extras

As I'll be coloring my artwork on computer, I've drawn the sound effects and the knife separately; they can be applied as separate layers and positioned precisely once the figures are in place. I'll show you more about lettering effects on pages 86–87.

⑤

⑥ Color background

This is quite a sophisticated scene in terms of its coloring. The balance of light and reflections in the wet road surfaces are not easy to achieve. This is one of those instances when having done a rough color version first makes life a lot easier. With the color and tones finally settled, it was rather fun to add the graffiti, trying to emulate different styles.

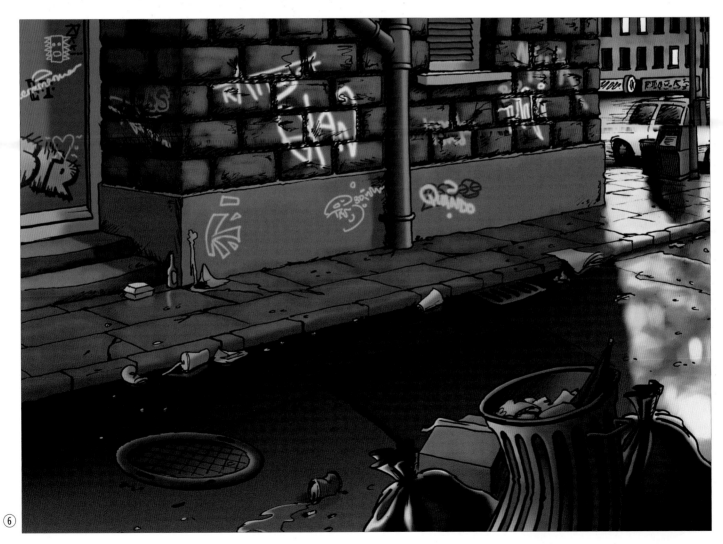

⑥

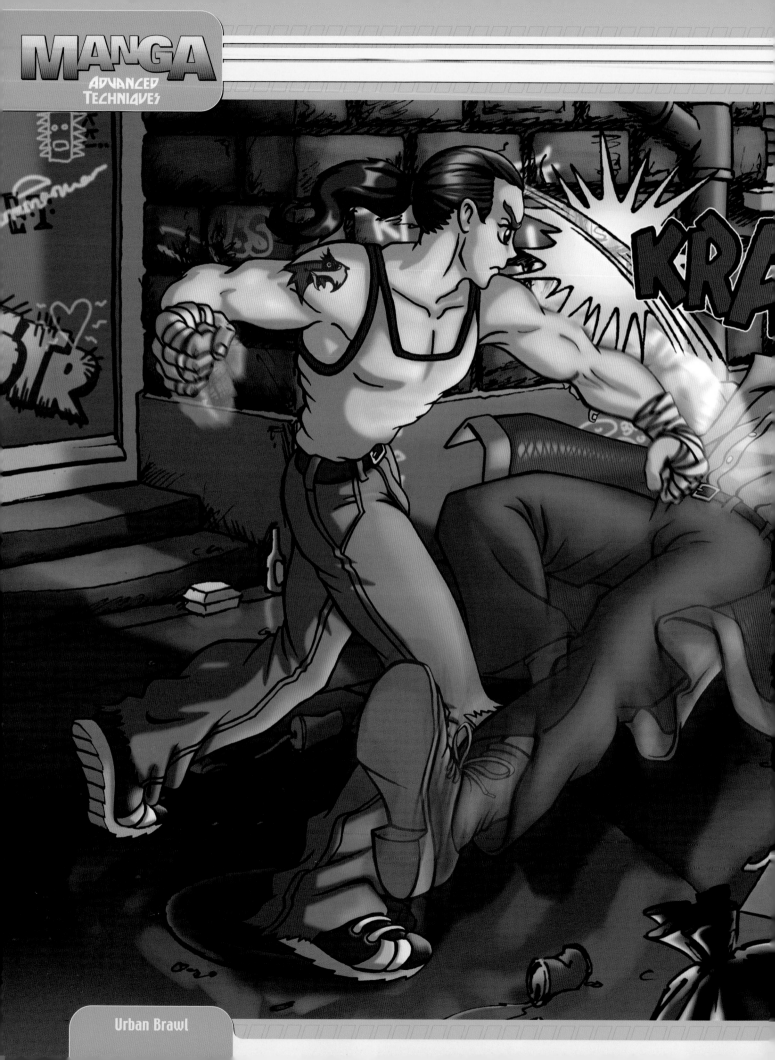

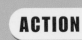

Completed artwork

Placing the figures and lettering involved a bit of juggling until their positioning looked right. Then I added their shadows and reflections on the ground and experimented with motion blurring effects, so emphasizing the movement. A white line around the lettering makes it clearly visible. I decided against any further highlighting of the figures because they stand out quite well enough.

PROJECTS

So far, we've covered a wide variety of manga genres and looked at lots of ways in which single pictures can be constructed to suggest a narrative. Here, we are going to examine how individual pictures can be assembled to tell an extended and carefully orchestrated story—in other words, we're going to create parts of a comic book.

I'll start by taking you through the stages of designing the first page of a comic book and then show you how to create a title page. To show you the power of images alone, we won't be adding any dialogue.

Most stories essentially begin with a state of equilibrium, or calm, and then some event occurs to break that calm. The remainder of the story is a series of efforts to overcome the upset and restore equilibrium.

But before even picking up a pencil, we'll need a scenario and a rough script to work to ...

THE BRIEF

Daisy and Duke have gone away to a mountain retreat, so that they can work on their latest manga story. Their log cabin is out in the wilderness, miles from the nearest town. Duke has gone out to get some supplies, leaving Daisy all alone —and there's something lurking in the forest. In a few pictures—or as they are called in comics, panels—the aim is to convey where the story is set along with a sense that something is about to happen, culminating in a disturbance that intrigues the reader enough to turn over the page.

PROJECTS
PROJECTS
PROJECTS
PROJECTS
PROJECTS
PROJECTS
PROJECTS
PROJECTS
PROJECTS
PROJECTS
PROJECTS
PROJECTS
PROJECTS
PROJECTS
PROJECTS
PROJECTS
PROJECTS

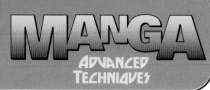

Comic Strip

The first stage of designing a comic strip layout is to work out what each panel should contain and decide on the order in which the panels should run. This is known as story-boarding. These drawings should be simple and quick—no one else will ever need to see them, so they only have to make sense to you.

Step 1

Panels 1, 2, and 3 show the environment—they gradually tell us what's going on through the window of the cabin. In panel 4, we find out that we aren't the only observers of the scene—and then realize that the previous three panels are what this mysterious figure is seeing as he approaches the cabin. Panel 5 reinforces the equilibrium hinted at in panel 3 and shows more detail of Daisy—what she's doing and the fact that she's alone. In panel 6 the mystery character gives away his presence. Daisy reacts. Her expression then turns to horror. In Panel 9 we see what she is horrified by. The fact that we still don't see the intruder keeps us intrigued.

Step 2

Now we need to choose the best shape, size, and composition for each individual panel. Your ideal pictures are unlikely to fit together perfectly—compromises have to be made to get each panel to work in its own right and to fit within an overall page design. There is clearly more work to be done.

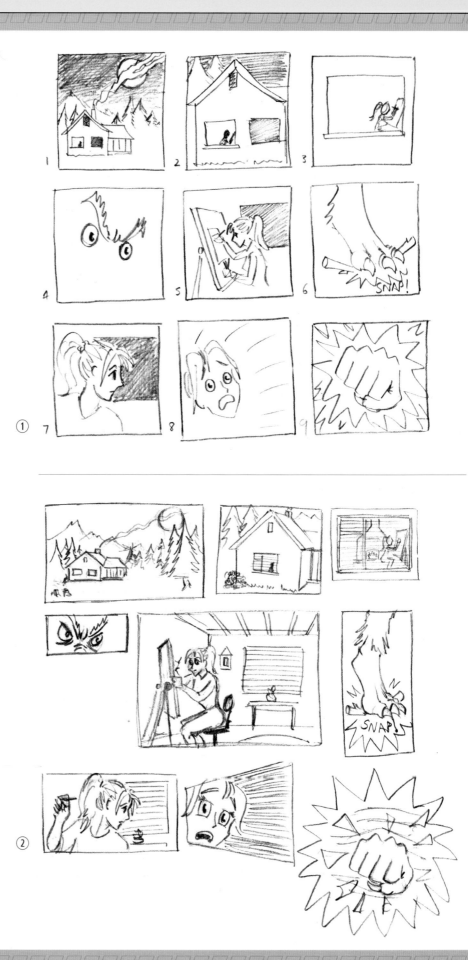

Step 3

The panels can be made to fit together by adjusting their shapes, sizes and positions. This looks pretty good as a rough layout.

Step 4

All the while you have to bear in mind what the color and tone of the panels will look like in the final artwork. In this story, half the panels are set outside and half inside. The outdoor pictures will be inked and colored much more heavily than the others. This gives us a problem—all the dark pictures are together in one corner of the page.

Step 5

In order to balance the tones on the page, I've had to change the format of some of the panels.

Step 6

By shading the panels again, we can see that these further adjustments have led to a much more balanced page. Just as we saw with single pictures, the overall composition is essential to a quality piece of work.
▶▶

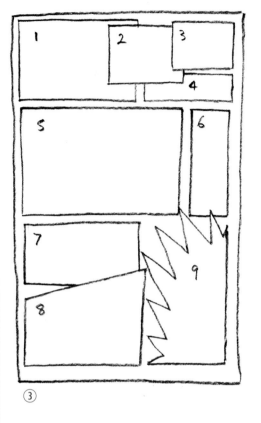

③

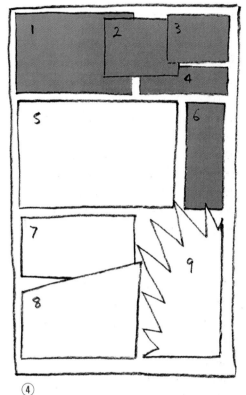

④

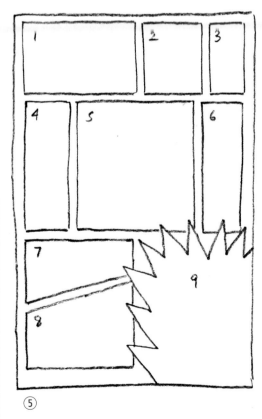

⑤

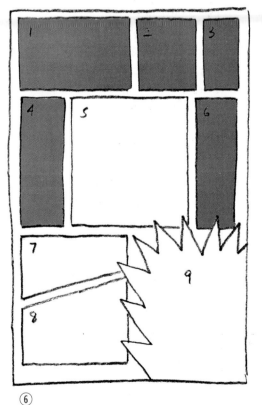

⑥

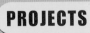

Step 7

Before I started making a pencil sketch of my storyboard idea, I decided that I would make a couple of additional changes to the panels. I started the page with an extra panel showing a full moon to hint that something spooky might be about to happen. For the final panel, I thought that an open hand might look more threatening than a fist, and that a sound effect would add impact to the action.

I mapped out this page roughly with a hard pencil then worked up the details with a softer one.

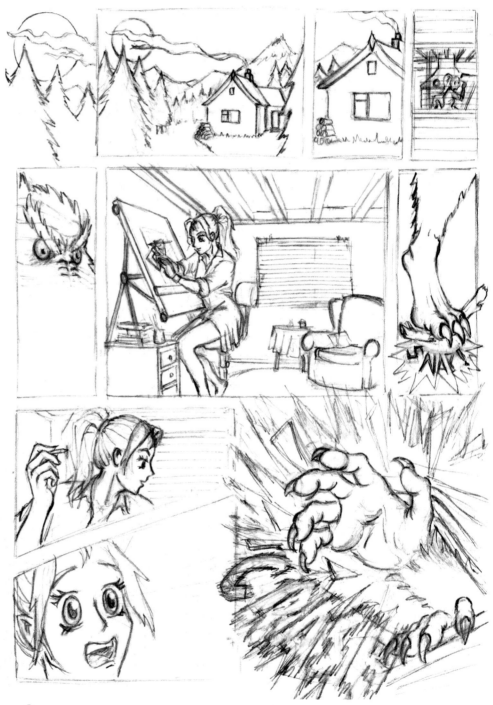

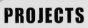

Step 8

I'm going to use a lot of solid black on this page. If you do this, you need to think carefully about it since it's easy to get carried away when you open the bottle of ink! First I go over the lines of my pencil sketch with a black fine-tipped pen, using a ruler for the panel edges. Then I can erase all my pencil marks. Compare this page to the following one to see the difference made by darker inking.

»

<<
Step 9

Fleshing out some lines with a thicker pen and adding solid black to the panels that are set outdoors gives the drawing a real lift. I also used the black for the spaces between the panels to give the page a unified design. I haven't ruled off the first panel of the moon, and I've allowed the sound effects to break out of their panels. Simple tricks like these add variety and interest to the page.

Finished artwork

In a sense, a lot of the coloring decisions were made when I refined the inking at the previous stage. The main thing here is to retain the distinction between the outdoor panels and those set indoors. Cool, dark shades as opposed to warm, bright colors.

So that's the introductory page of my story finished. Now it needs a title page to really grab the reader's attention. Before we look at the titling I devised, let's look first at the kinds of effects which can be achieved by adding words to your pictures.

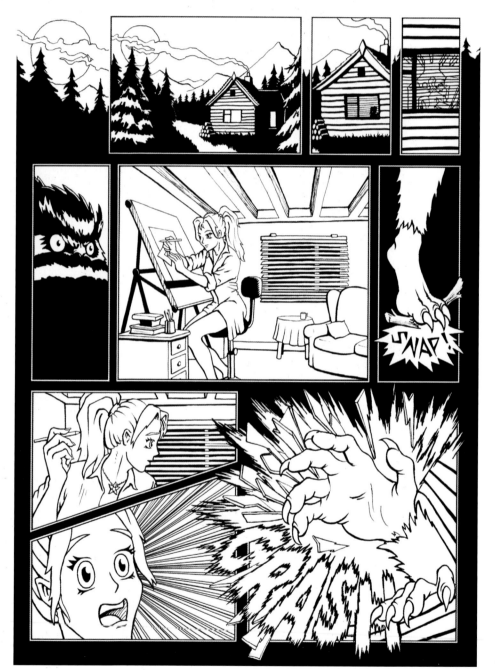

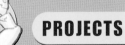

Lettering and sound effects

On page 74 the addition of a single word to the fight scene had the effect of exaggerating the impact of the punch. Such devices are known as sound effects and are used extensively in manga, in some manga comics in nearly every panel. Here's a very brief look at the kinds of effects you can achieve with the design and placement of words in your manga pictures.

Bang 1, Bang 2

Bang is typical of the kinds of words used in manga. It's one of those words that sounds like its meaning. But the word alone is not enough for a dramatic manga effect. For a start, it needs to be written, or rather,

drawn in an appropriate style. Precisely designed and spaced lettering is not as effective as roughly proportioned letters, skewed and overlapping. In these cases an exclamation mark is often a good idea.

The meaning of the word can take on different associations depending on the context and the way the word is presented. In these examples, exactly the same lettering seems to make a different sound. In the first, the sound appears to be muffled by the cloud design and suggests a dull explosion. In the other, the shape of the outline suggests a sharper sound, such as a heavy blow or objects striking against each other.

Arrrghh! 1

Here are more examples where roughly drawn lettering is more effective than neatness. Duke's clearly in pain judging by the look on his face so, one could argue that the lettering is unnecessary. But this is manga, where drama is all-important. The lettering reinforces Duke's emotion with its angular shape and increasing size, as well as the meaning of the word itself.

Arrrghh! 2

Same word, different emotion. With a more wobbly shape to the letters and a change of expression on Duke's face, Arrrghh! becomes a cry of fear rather than pain.

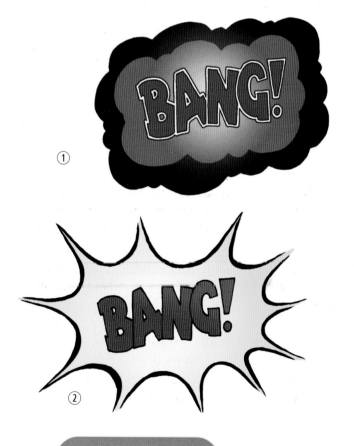

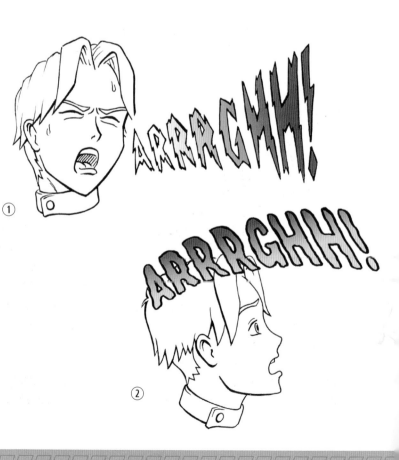

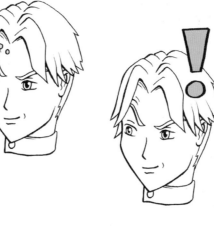

Using Symbols

Lettering is not only used for sound effects, more subtle expressions can be drawn out of the considered use of letters and symbols. Here, Duke's quizzical expression can be read in three different ways. The implication in each of these is not of noise, but of thought.

①

②

③

Designing a logo

Now that we've looked at what can be achieved with simply drawn sound effects, let's consider applications where you'll need to spend more time designing the lettering.

① Logo line

Here's a logo I've been working on for Daisy's comic. It had to go through several stages of development to realize my idea of Daisy's character: gentle and rounded and yet also angular and dynamic.

② Logo outline

Once a logo is designed, there are many decisions yet to be made about it's final rendering. In this trial I've coloured it in flat red and added an outline—very manga. To do it yourself make sure that the outline is the same width all the way around the letters and don't forget the areas inside and between the letters.

③ Logo shadow

Another common manga lettering device is known as drop shadow. To achieve this effect you need two versions of the lettering, exactly the same shape in outline. One is offset from the other and when coloured or shaded in a darker tone, it gives the impression of a shadow underneath raised lettering. In this example, I've also added a few basic highlights to increase the suggestion of light and shade.

To see the final rendering of Daisy's logo, turn to the 'title page' section on page 95.

Title Page

In the previous exercise, we set the scene with the first page of our comic strip story. Now I'll show you how to design the title page of the story. Just like in movies and television dramas, the tension in a comic is often built up before the title is introduced.

The brief

This picture should be the revealing moment—when we see the intruder for the first time. It's effectively the next panel of our story. It should convey Daisy's plight and the impending danger. First I need to decide on the composition of our picture, which I've done by making some rough sketches.

Rough 1

I want to show the difference in scale between the two characters, but here the beast takes up too much space in the picture. This kind of composition would work well for a smaller panel, but not here.

Rough 2

This could work better because the mass of the beast's body serves as a fairly plain background to the lettering. Daisy looks suitably cornered, but I think we ought to see more of the beast's face.

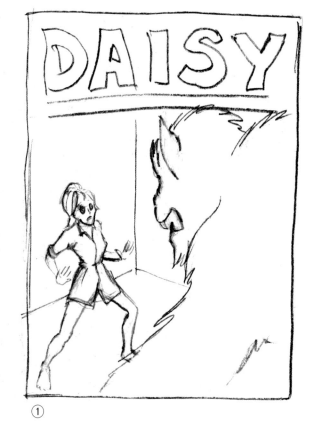

①

②

Rough 3

Shadows are great for creating mystery but I don't think this approach will work for the title page. I like Daisy's pose, though, so let's look at the scene from the other way around.

Rough 4

This is much better. The beast and Daisy are both in full view. The size of the beast is apparent, and there's space around them to show some background detail and the disarray of the room.

»

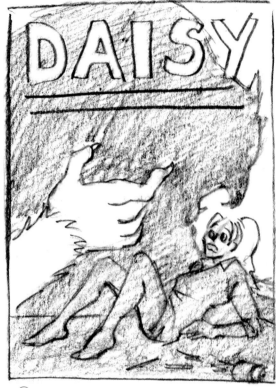

③

When you are creating your own character, try copying a friend's hairstyle and look in a catalogue for clothing ideas. Borrow bits from manga characters on TV too.

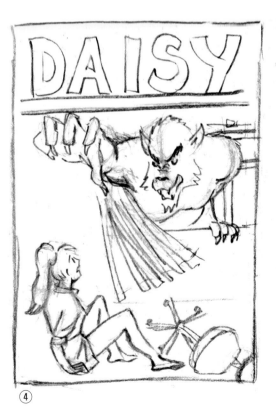

④

① Pencil drawing

Once I had worked out where to put the figures, I decided to skew the picture to add to the impact—this changes the perspective, making the beast tower over Daisy even more as she cowers in the corner. At this stage I'm only concerned with the basic shapes and perspective which I've roughly sketched in with a hard pencil.

② Adding detail

The expressions of Daisy and the beast are crucial to the impact of the picture, so I've spent some time on them. I've added the furniture and the slats of the broken blind the beast has burst its way through. These details are added with a softer pencil over very rough guidelines.

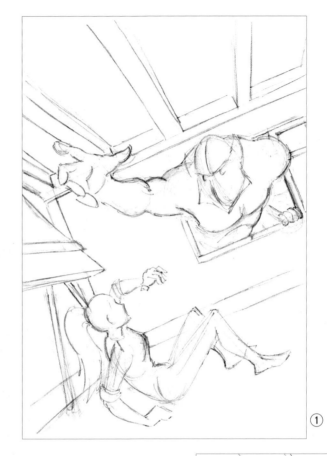

①

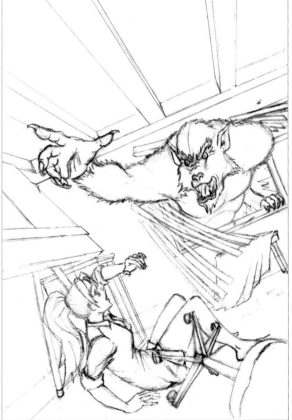

②

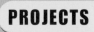

③ Simple ink line

Once I was satisfied with my pencil sketch, I carefully inked over all my final lines with a black felt-tip pen. When the ink was dry, I erased all my pencil marks.

④ Finished ink line

Now I strengthen the line and add a few areas of black, especially around the beast's eyes. Now the picture is ready to be colored. I'll break down the computer coloring into simple stages so that you can produce similar results with your own pictures.

Scanning and Preparation

Once you have your final ink drawing, you are ready to scan it in. It's best to scan at a high resolution —say 500 dpi—and as grayscale. This gives crisper lines later on and eliminates the risk of a color cast from your scanner. When you are in Photoshop, reduce the resolution to about 300 dpi. That's about the maximum you'll need to print with, and larger sizes will only slow your computer down. Convert the image (In Image>Mode>) to RGB. This is a good time to look at your work close up and clean any large blotches and imperfections. Use the Eraser tool for this. Making sure your background color is white, Select All (Apple + A) and make New Layer Via Cut (Apple + Shift + J). Set the Blending Mode of this layer to Multiply, name it 'Line Art' and then Lock it. You shouldn't need to touch your original artwork again.

»

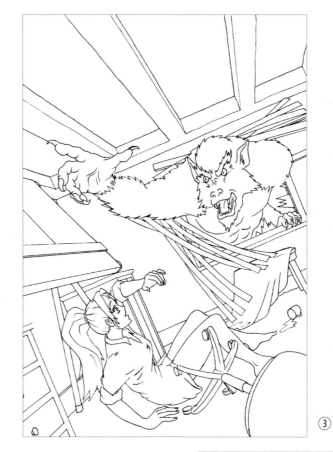

③

④

⑤–⑥ First color

On a layer below your black and white drawing, start putting down the flat colors. You have to get rid of the white areas first. In our first illustration you can see that the main color used is the warm brown of the cabin walls. I used the Lasso and Bucket and Magic Wand tools to put down this broadest area of color. In the second picture I used a dark brown to roughly cover the area of the floor. Select this area with the Lasso tool. You'll find it easier if you magnify the image quite a lot and use the Polygon Lasso tool to make your selections. Fill it up using the Bucket tool.

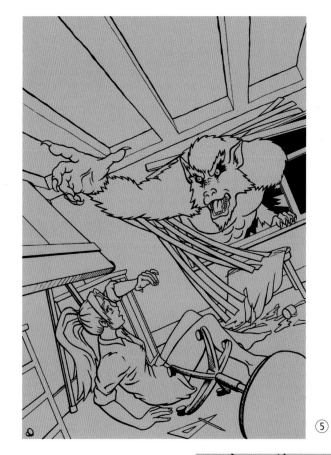

⑤

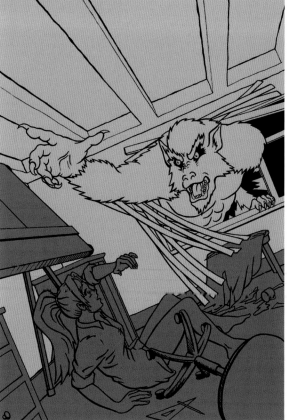

⑥

⑦ Second color

Select what will be the next largest area of color. You can fill it with the Bucket, or alternatively change the color using Image > Adjustments > Hue/Saturation (Apple + U). I decided to mark out the dark color of the wolf-creature's furry coat.

Hint: After drawing out your rough selection area, you can use the Magic Wand with the Alt key pressed down to deselect any different-colored areas you may have accidentally included.

⑧ Flat color

Once you've got all the areas of flat color down, merge these color layers, name it 'Flat Color' and Lock it. You shouldn't need to change it again, but it will prove useful with the Magic Wand tool later on. Make a new layer. We'll be working on this new layer from now on. Save your work. (You have been saving regularly, haven't you?)

≫

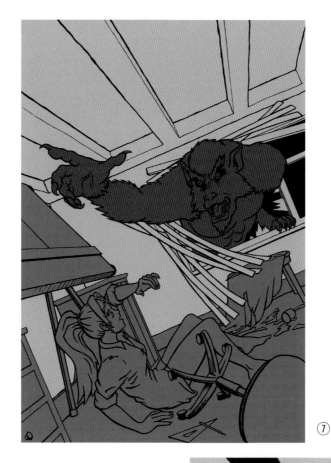

⑦

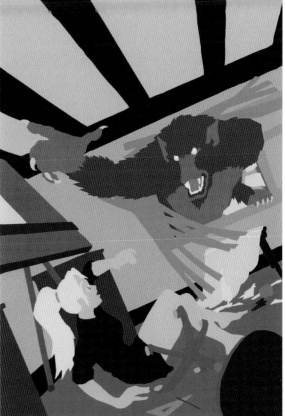

⑧

<<

⑨ Shading

Time to put on some shadows. For this we'll be using Quick Mask. Click on the Quick mask icon, or just press Q. Using the Brush tool, paint an area you want to be in shadow. Don't worry about going over the lines—we'll be fixing that shortly.

To check what you've just done, leave Quick Mask mode (again Q or the icon in the tool palette). You'll see that you've actually selected an area of the image. For a more feathered selection you can use a softer brush. Now you can clean up the selection by going to your 'Flat Color' layer and using Alt + the Magic Wand tool just as you did earlier. Go back to your working layer and use Image > Adjustments > Hue/Saturation to shade to your taste, or just fill it up with the Bucket tool.

⑩ Highlights

If you would like exact control over the area of highlight, you can magnify the image and use the Lasso tool to select the shapes you want, then lighten them with the Hue/Saturation command. This is the way I worked on Daisy's hair. For most of the images in this book I used the Dodge tool, which softly lightens colors wherever it is applied. If you prefer a more painterly style of shading, you can use it and the Magic Wand to mask off the areas you're working on.

Your finished artwork is now ready to print out.

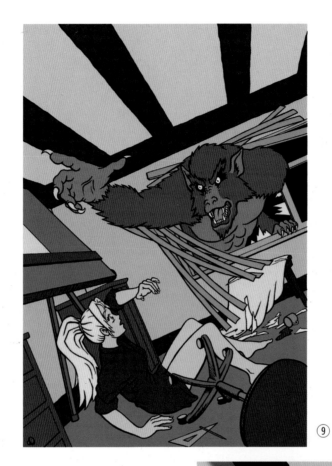

⑨

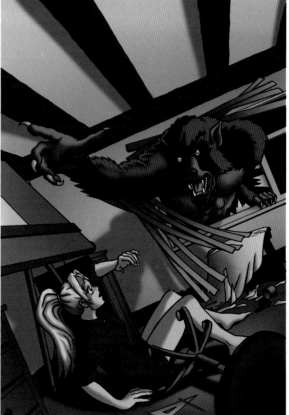

⑩

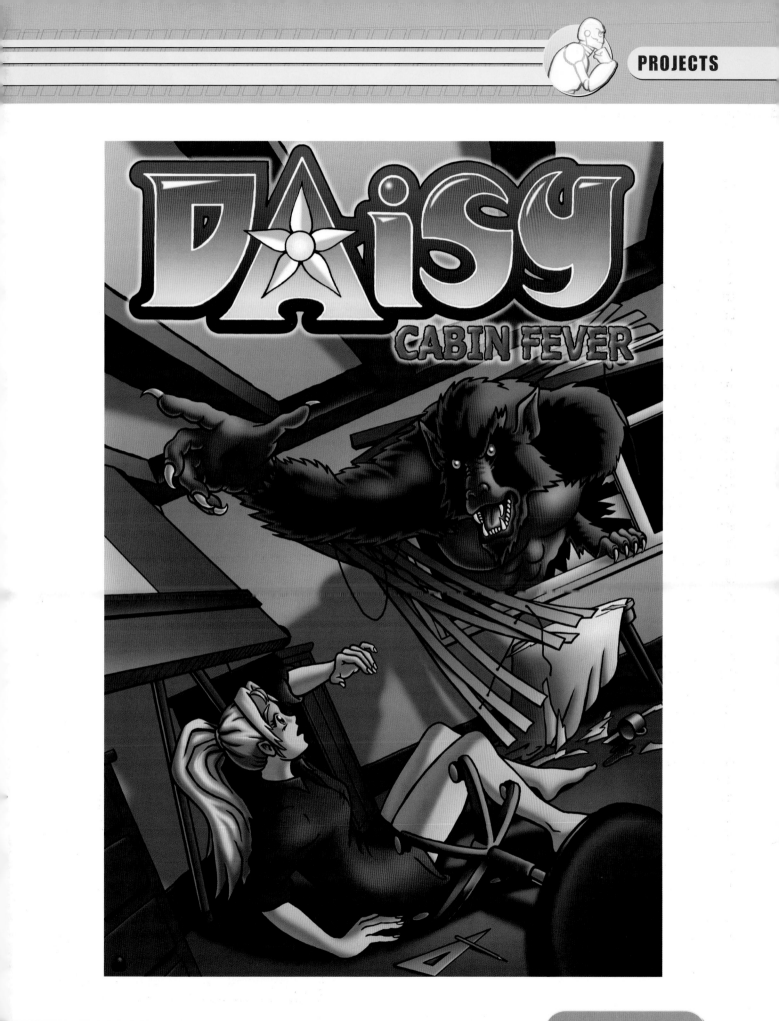

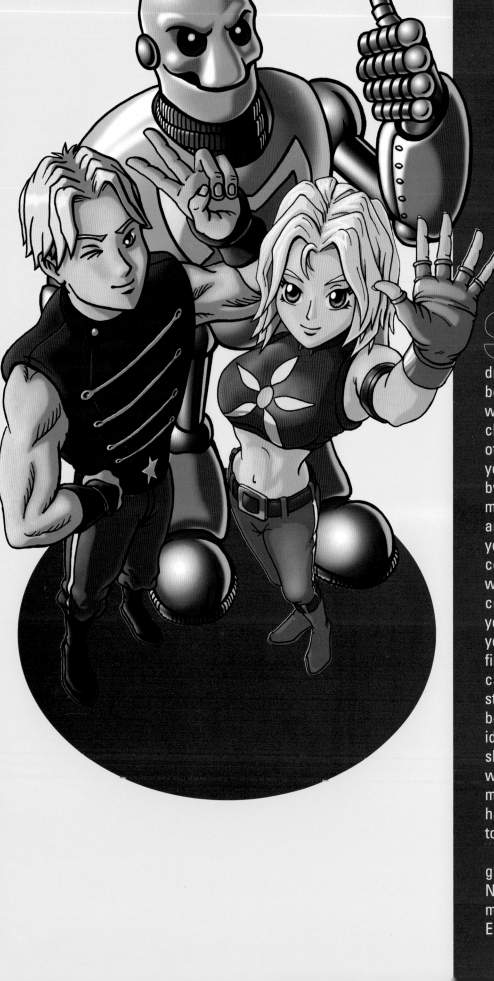

So that's it—except that you can always do more to improve your manga drawings. All the scenes in this book need to be complemented by well-drawn figures, so practicing character drawing is crucial. The other books in this series can help you do this if you follow their step-by-step instructions to drawing manga males, females, mechas, and monsters in action. Now that you've taken a stab at starting a comic strip, you could storyboard what might happen next—or create storyboards for adventures you think up yourself. For this you'll need inspiration which you'll find in the world around you. You can base your ideas on real news stories and your characters might be people you know. Any time an idea strikes you, jot it down or sketch it. Even if you can't think what to do with it immediately, you might find a place for it once you have a batch of ideas to thread together.

Duke, Daisy and Magnus have given you all the help they can. Now it's down to you to become a master of your manga destiny. Enjoy the journey!